二十四式
簡化太極拳

掃碼優酷學習

掃碼 YouTube 學習

Twenty Four Taijiquan

《國際武術大講堂系列教學》
編委會名單

名 譽 主 任：冷述仁

名譽副主任：桂貴英

主　　　　任：蕭苑生

副　主　任：趙海鑫　張梅瑛

主　　　　編：冷先鋒

副　主　編：鄧敏佳　鄧建東　陳裕平　冷修寧　冷雪峰　冷清鋒

　　　　　　冷曉峰　冷　奔

編　　　　委：劉玲莉　張貴珍　李美瑤　張念斯　葉旺萍　葉　英

　　　　　　陳興緒　黃慧娟（印尼）　葉逸飛　陳雄飛　黃鈺雯

　　　　　　王小瓊（德國）　葉錫文　翁摩西　梁多梅　ALEX（加拿大）

　　　　　　冷　余　鄧金超　冷飛鴻　PHILIP（英國）金子樺

顧　　　　問：何光鴻　柯孫培　馬春喜　陳炳麟

法律顧問：王白儂　朱善略　劉志輝

《24式簡化太極拳》
編委會名單

主　　編：冷先鋒　鄧敏佳

副主編：金子樺　李美瑤

編　　委：鄧建東　陳裕平　張念斯　葉旺萍　周煥珍　陳興緒

　　　　　冷飛鴻　何淑貞　黃綠英　鄭安娜　冷飛彤　陳曉澄

　　　　　陳志昂　莊那宏　冷熙然　陳雄飛　黃鈺雯　歐陽美光

　　　　　莫麗芬　張貴珍　余　瓊　許依玲　吳天成　翁梅麗（印尼）

　　　　　梁多梅　黃碧玉　何玉清　王子娟　李國光　艾力（加拿大）

　　　　　楊海英　吳志強　崔順儀　劉嘉晴　林敬朗　王振名（臺灣）

　　　　　黃春燕　杜知江　戴裕強　甘鳳群　張晉豪　王小瓊（德國）

　　　　　謝璧璣　吳小平　陳顥玲　吳鵬儀（加拿大）

翻　　譯：黃倚晴（Chloe Wong）　Philip Reeves（英國）

冷先鋒簡介

江西修水人，香港世界武術大賽發起人，當代太極拳名家、全國武術太極拳冠軍、香港全港公開太極拳錦標賽冠軍、香港優秀人才，現代體育經紀人，自幼習武，師從太極拳發源地中國河南省陳家溝第十代正宗傳人、國家非物質文化遺產傳承人、國際太極拳大師陳世通大師，以及中國國家武術隊總教練、太極王子、世界太極拳冠軍王二平大師。

中國武術段位六段、國家武術套路、散打裁判員、高級教練員，國家武術段位指導員、考評員，擅長陳式、楊式、吳式、武式、孫式太極拳和太極劍、太極推手等。在參加國際、國內大型的武術比賽中獲得金牌三十多枚，其學生弟子也在各項比賽中獲得金牌四百多枚，弟子遍及世界各地。

二零零八年被香港特區政府作為"香港優秀人才"引進香港，事蹟已編入《中國太極名人詞典》、《精武百傑》、《深圳名人錄》、《香港優秀人才》；《深圳特區報》、《東方日報》、《都市日報》、《頭條日報》、《文彙報》、《香港01》、《星島日報》、《印尼千島日報》、《國際日報》、《SOUTH METRO》、《明報週刊》、《星洲日報》、《馬來西亞大馬日報》等多次報導；《中央電視臺》、《深圳電視臺》、《廣東電視臺》、《香港無線 TVB 翡翠臺》、《日本電視臺》、《香港電臺》、《香港商臺》、《香港新城財經臺》多家媒體電視爭相報導，並被美國、英國、新加坡、馬來西亞、澳大利亞、日本、印尼等國際幾十家團體機構聘為榮譽顧問、總教練。

冷先鋒老師出版發行了一系列傳統和競賽套路中英文 DVD 教學片，最新《八法五步》、《陳式太極拳》、《長拳》、《五步拳》、《陳式太極劍》、《陳式太極扇》、《太極刀》、《健身氣功八段錦》、《五禽戲》等中英文教材書，長期從

事專業的武術太極拳教學，旨在推廣中國傳統武術文化，讓武術太極拳在全世界發揚光大。

　　冷先鋒老師本著"天下武林一家親"的理念，以弘揚中華優秀文化為宗旨，讓中國太極拳成為世界體育運動為願景，以向世界傳播中國傳統文化為使命，搭建一個集文化、健康與愛為一體的世界武術合作共贏平臺，以平臺模式運營，走產融結合模式，創太極文化產業標杆為使命，讓世界各國武術組織共同積極參與，達到在傳承中創新、在創新中共享、在共用中發揚。為此，冷先鋒老師於 2018 年發起舉辦香港世界武術大賽，至今已成功舉辦兩屆，盛況空前。

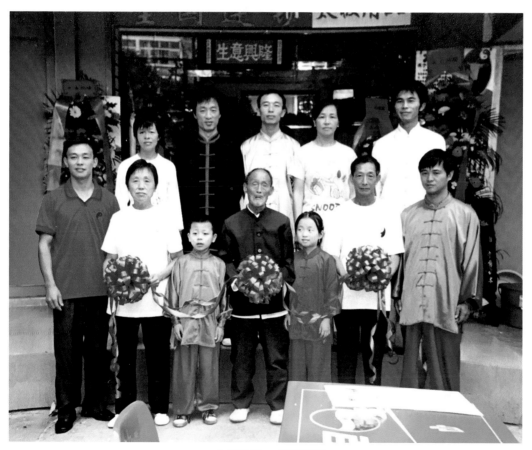

太極世家　　四代同堂

Profile of Master Leng Xianfeng

Originally from Xiushui, Jiangxi province, Master Leng is the promoter of the Hong Kong World Martial Arts Competition, a renowned contemporary master of taijiquan, National Martial Arts Taijiquan Champion, Hong Kong Open Taijiquan Champion, and person of outstanding talent in Hong Kong. A modern sports agent, Master Leng has been a student of martial arts since childhood, he is a 11th generation direct descendant in the lineage of Chenjiagou, Henan province – the home of taijiquan, and inheritor and transmitter of Intangible National Cultural Heritage. Master Leng is a student of International Taiji Master Chen Shitong and Taiji Prince, Master Wang Erping, head coach of the Chinese National Martial Arts Team and World Taiji Champion.

Master Leng, level six in the Chinese Wushu Duanwei System, is a referee, senior coach and examiner at national level. Master Leng is accomplished in Chen, Yang, Wu, Wu Hao and Sun styles of taijiquan and taiji sword and push-hands techniques. Master Leng has participated in a series of international and prominent domestic taijiquan competitions in taiji sword. Master Leng has won more than 30 championships and gold medals, and his students have won more than 400 gold medals and other awards in various team and individual competitions. Master Leng has followers throughout the world.

In 2008, Master Leng was acknowledged as a person of outstanding talent in Hong Kong . His deeds have been recorded in a variety of magazines and social media. Master Leng has been retained as

an honorary consultant and head coach by dozens of international organizations in the United States, Britain, Singapore, Malaysia, Australia, Japan, Indonesia and other countries.

Master Leng has published a series of tutorials for traditional competition routines on DVD and in books, the latest including "Eight methods and five steps", "Chen-style taijiquan", "Changquan", "Five-step Fist" and "Chen-style Taijijian","Chen-style Taijishan","Taijidao", "Health Qigong Baduanjin","Wuqinxi".Master Leng has long been engaged as a professional teacher of taijiquan, with the aim of promoting traditional Chinese martial arts to enable taijiquan to spread throughout the world.

Master Leng teaches in the spirit of "a world martial arts family", with the goal of "spreading Chinese traditional culture, and achieving a world-wide family of taijiquan." He promotes China's outstanding culture with the vision of "making taijiquan a popular sport throughout the world". As such, Master Leng has set out to to build an international business platform that promotes culture, health and love across the world of martial arts practitioners to achieve mutual cooperation and integrated production and so set a benchmark for the taiji culture industry. Let martial arts organizations throughout the world participate actively, achieve innovation in heritage, share in innovation, and promote in sharing! To this end, Master Leng initiated the Hong Kong World Martial Arts Competition in 2018 and has so far successfully held two events, with unprecedented grandeur.

 # 冷先鋒太極（武術）館

中華武術

火熱招生中......

地址：深圳市羅湖區紅嶺中路1048號東方商業廣場一樓、三樓

電話：13143449091　　13352912626

【名家薈萃】

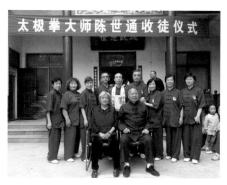

陳世通收徒儀式

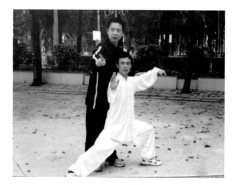

王二平老師

趙海鑫、張梅瑛老師

武打明星梁小龍老師

王西安老師

陳正雷老師

余功保老師

林秋萍老師

門惠豐老師

張山老師

高佳敏老師

蘇韌峰老師

李德印教授

錢源澤老師

張志俊老師

曾乃梁老師

郭良老師

陳照森老師

張龍老師

陳軍團老師

【名家薈萃】

劉敬儒老師

白文祥老師

張大勇老師

陳小旺老師

李俊峰老師

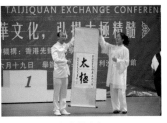

戈春艷老師

李德印教授

馬春喜、劉善民老師

丁杰老師

付清泉老師

馬虹老師

李文欽老師

朱天才老師

李傑主席

陳道雲老師

馮秀芳老師

陳思坦老師

趙長軍老師

【獲獎榮譽】

【電視采訪】

【電視采訪】

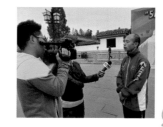

【電臺訪問】

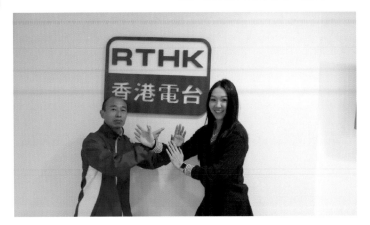

【合作加盟】

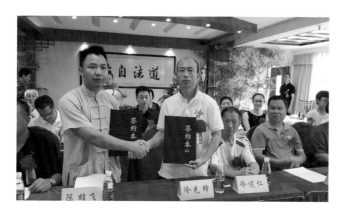

【媒體報道】

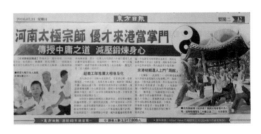

【培訓瞬間】

百城千萬人太極拳展演活動　　　　　雅加達培訓

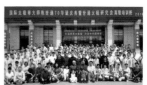

汕頭培訓　　　　王二平深圳培訓　　　　師父70大壽

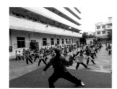
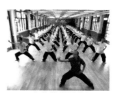

香港公開大學培訓　　印度尼西亞培訓　　松崗培訓　　香港荃灣培訓

王二平深圳培訓　　　陳軍團香港講學　　　印尼泗水培訓

油天培訓　　　印尼扇培訓　　　七星灣培訓　　陳軍團香港講學培訓

油天培訓　　　　美國學生　　　　馬春喜香港培訓班

【賽事舉辦】

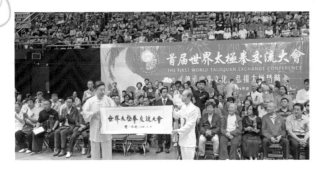

首屆世界太極拳交流大會

第二屆"太極羊杯"香港世界武術大賽

第二屆"太極羊杯"大賽

日本德島國際太極拳交流大會

首屆世界太極拳交流大會

馬來西亞武術大賽

東莞擂臺表演賽

首屆永城市太極拳邀請賽

首屆永城市太極拳邀請賽

2018首屆香港太極錦標賽

2019首屆永城市太極拳邀請賽

【專賣店】

金子樺簡介

　　金子樺老師，畢業於香港中文大學工商管理學系，自幼學習北少林武術，現師從當代太極拳名家、陳氏太極第十一代正宗傳人冷先鋒老師，是香港太極總會及香港國際武術總會教練、香港中國國術龍獅總會及香港國際武術總會裁判、國際康體專才培訓學院伸展導師。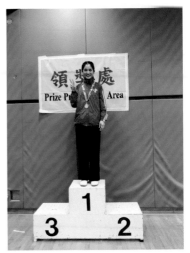

　　金子樺老師在多項本地及外地太極比賽中屢獲獎項，其中包括太極拳、劍、扇等獎牌三十多枚。金子樺老師曾多次到不同學校作交流表演，現為香港國際武術總會及多所學校和機構的氣功及太極導師，學生年齡遍佈三歲到八十多歲。近年更在社交媒體設立專頁，宣揚太極及養生之道，並視此為其終身職業。

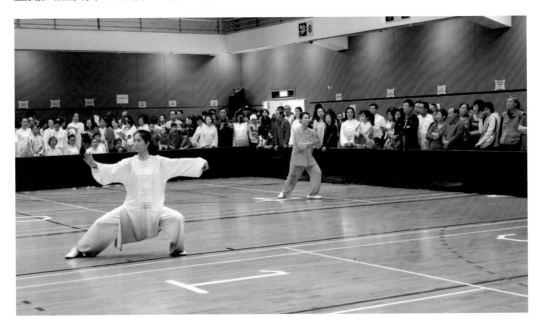

Profile of Master Zukina Kam

Master Zukina Kam graduated from the Chinese University of Hong Kong with a degree in Business Administration. She practiced Bei Sholin Wushu at a young age. She is a student of the 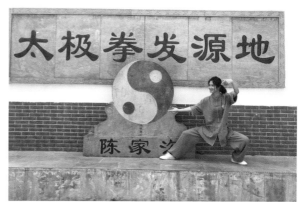 living Taiji Master Leng Xianfeng, who is the 11th generation descendent in the lineage of Chen-style taijiquan. Master Kam is a qualified Taiji trainer of the Hong Kong Taiji Association and the Hong Kong International Wushu Association, referee of the Hong Kong Chinese Martial Arts Dragon and Lion Dance Association and the Hong Kong International Wushu Association as well as stretching instructor of the International Personal Trainers and Fitness Academy.

Master Kam has won more than thirty medals and trophies in a number of local and foreign Taiji competitions, including Taiji fist, sword and fan. She was invited by various schools for Taiji exchanges, she is now both the Qigong and Taiji trainer of the Hong Kong International Wushu Association and various schools and institutions, with the students' age from 3 to the eighties. In recent years, she has set up her own fan page in social medias to promote Taiji and health-preserving issues and she regards this as her life-long career.

獲得高級裁判員、教練員

馬春喜老師

陳家溝陳軍團老師

李德印老師

陳世通大師

高佳敏老師

穆秀杰老師

陳小旺老師

香港小學武術班

獲得冠軍

陳家溝太極拳學校

香港社區班

太極劍比賽

香港公開大學授課

九龍公園太極班

目　　錄
DIRECTORY

注釋：　白：代表左腳，黑：代表右腳。

表示前腳掌着地。

表示腳跟着地。

表示其中一只腳懸空的動作。

代表右手右腳路綫

代表左手左腳路綫

1

第一式 起勢
Commencing Form

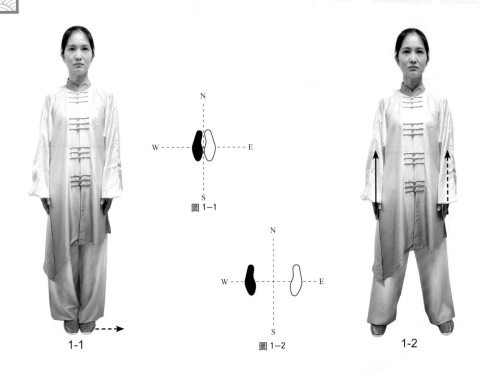

圖 1-1

圖 1-2

1-1

1-2

1. 并腳直立 Stand upright with feet together

身體自然直立，兩手鬆垂輕貼大腿外側，目視前方。（圖 1-1）

Body naturally upright, arms relaxed with palms resting lightly on outside of thighs, look straight ahead.(Fig. 1-1)

2. 開步肩寬 Step shoulder width apart

左腳向左橫開一步，與肩同寬，目視前方。（圖 1-2）

Move the left foot one step to the left, with feet shoulder-width apart, look straight ahead. (Fig. 1-2)

第一式 起勢
Commencing Form

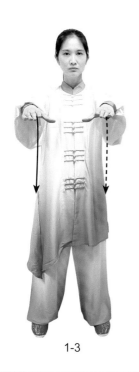

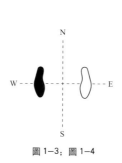

圖 1−3；圖 1−4

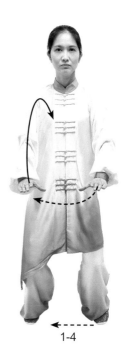

1-3

1-4

3. 兩臂平舉 Raise arms to shoulder level

兩臂向前、向上慢慢平舉，與肩同高，力點在兩手前臂，目視前方。 （圖 1-3）

Raise arms slowly forwards and upwards to shoulder level, the point of force at both forearms, look straight ahead. (Fig. 1-3)

4. 屈膝下按 Bend knees and press down

屈膝鬆肩鬆胯，兩手向下按掌，微微坐腕，力達掌根，目視前下方。 （圖 1-4）

Bend knees, relax shoulders, relax hips, press down both arms, bend the wrists slightly, the point of force at bases of the palms, look ahead and downwards. (Fig. 1-4)

2

第二式 左右野馬分鬃
Parting the Wild Horse's Mane on Both Sides

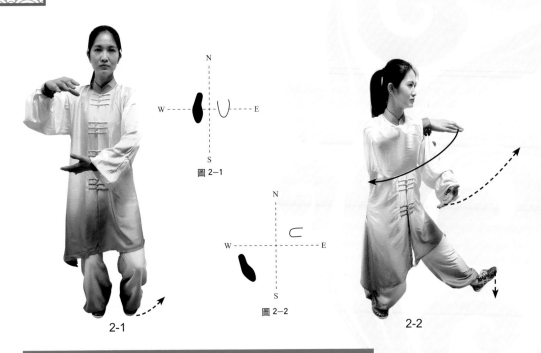

圖 2-1

圖 2-2

2-1

2-2

1、 收腳抱球 Withdraw foot and hold ball

重心移至右腳，兩掌在右胸前合抱，右手屈臂收在胸前，掌心向下，左手劃弧收至右胯前，掌心向上，同時左腳收到右腳內側，腳尖點地，目視右手。（圖 2-1）

Move the center of gravity to the right foot, two palms cross in front of the right chest, bend the right arm in front of the chest, palm down, left hand arc to the right hip, palm up, while the left foot steps to the inside of the right foot, point the toes to the ground, look at the right hand. (Fig. 2-1)

2、 左轉上步 Turn left and step forward

身體左轉，提左腳向左前方上步，腳跟先著地，目視左前方。（圖 2-2）

Turn left, step left foot forward to the left, heel first to touch the ground, look front left. (Fig. 2-2)

第二式 左右野馬分鬃
Parting the Wild Horse's Mane on Both Sides

2

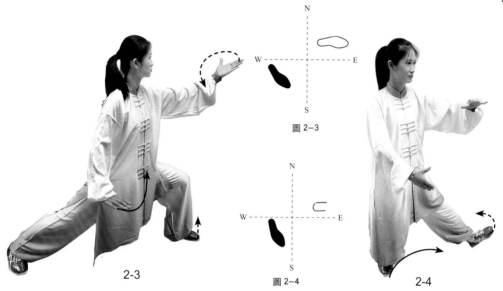

圖 2-3

2-3

圖 2-4

2-4

3、弓步分掌 Bow step and open palms

身體繼續左轉，重心左移，左腳前弓，右腳後蹬，成左弓步，同時兩手上下斜分，左手腕與肩平，掌心斜向上，右手收至右胯旁，掌心向下，目視左手。（圖 2-3）

Continue to turn left, the center of gravity moves to the left, left foot bow step forward, right foot pushes back into left bow stance, at the same time open both arms in an oblique direction, left wrist to shoulder level, palm oblique upwards, press right hand down to the right hip, palm down, look at the left hand. (Fig. 2-3)

4、後坐翻掌 Sit back and turn over palm

身體右轉，重心右移，左腳尖上翹，同時左掌內旋翻掌，掌心向下，目視左手。（圖 2-4）

Turn right, the center of gravity moves to the right, the left foot upturns, at the same time, the left palm turns downwards, look at the left hand. (Fig. 2-4)

第二式 左右野馬分鬃
Parting the Wild Horse's Mane on Both Sides

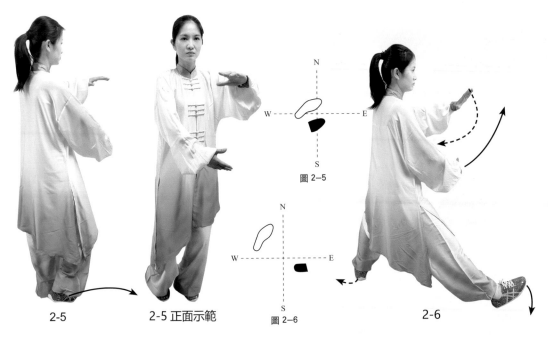

2-5 | 2-5 正面示範 | 圖 2-5 | 圖 2-6 | 2-6

5、 收腳抱球 Withdraw foot and hold ball

身體微左轉，重心移至左腳，右腳收至左腳內側，腳尖點地，同時右手外旋翻掌，收至左胯前，掌心向上，兩掌相抱，目視左手。（圖 2-5）

Turn left slightly, the center of gravity moves to the left foot, step right foot to the inside of the left foot, point the toes to the ground, at the same time right hand rotates externally and rest in front of the left hip, palm upwards, two palms face one another, look at the left hand. (Fig. 2-5)

6、右轉上步 Turn right and step forward

身體右轉，提右腳向右前方上步，腳跟先著地，目視右前方。 （圖 2-6）

Turn right, step right foot forward to the right, heel first to touch the ground, look front right. (Fig. 2-6)

第二式 左右野馬分鬃
Parting the Wild Horse's Mane on Both Sides

2

7、弓步分掌 Bow step and open palms

身體繼續右轉，右腳前弓，左腳後蹬，成右弓步，同時兩手上下斜分，右手腕與肩平，掌心斜向上，左手收至左胯旁，掌心向下，目視右手。（圖 2-7）

Continue to turn right, right foot bow step forward, left foot pushes back into right bow stance, at the same time open both arms in an oblique direction, right wrist and shoulder flat, palm oblique upwards, press left hand down to the left hip, palm down, look at the right hand. (Fig. 2-7)

8、後坐翻掌 Sit back and turn over palm

身體左轉，重心左移，右腳尖上翹，同時右掌內旋翻掌，掌心向下，目視右手。（圖 2-8）

Turn left, the center of gravity moves to the left, the right foot upturns at the same time, the right palm turns downwards, look at the right hand. (Fig. 2-8)

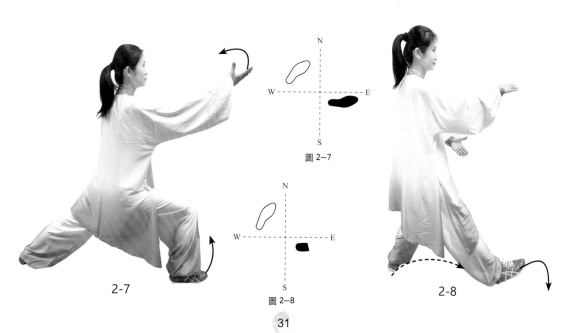

圖 2-7

圖 2-8

2-7

2-8

2

第二式 左右野馬分鬃
Parting the Wild Horse's Mane on Both Sides

9、收腳抱球 Withdraw foot and hold ball

重心移至右腳，兩掌在右胸前合抱，右手屈臂收在胸前，掌心向下，左手劃弧收至右胯前，掌心向上，同時左腳收到右腳內側，腳尖點地，目視右手。 （圖 2-9）

The center of gravity moves to the right foot, two palms cross in front of the right chest, bend the right arm in front of the chest, palm down, left hand arc to the right hip, palm upwards, while the left foot steps to the inside of the right foot, point the toes to the ground, look at the right hand. (Fig. 2-9)

10、左轉上步 Turn left and step forward

身體左轉，提左腳向左前方上步，腳跟先著地，目視左前方。 （圖 2-10）

Turn left, step left foot forward to the left, heel first to touch the ground, look front left. (Fig. 2-10)

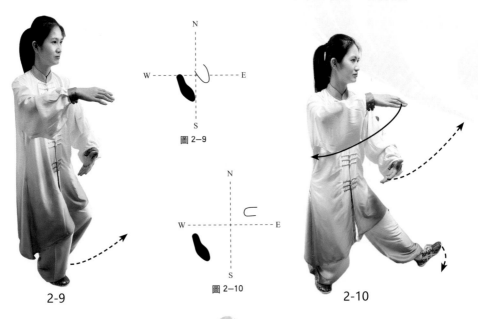

圖 2-9

圖 2-10

2-9

2-10

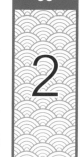

第二式 左右野馬分鬃
Parting the Wild Horse's Mane on Both Sides

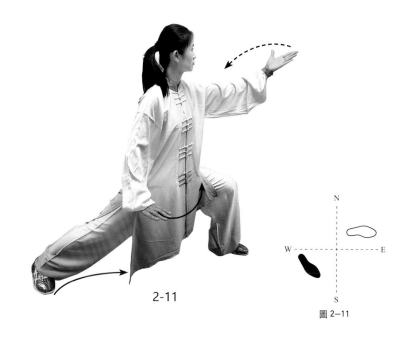

2-11

圖 2-11

11、弓步分掌 Bow step open palms

身體繼續左轉，重心左移，左腳前弓，右腳後蹬，成左弓步，同時兩手上下斜分，左手腕與肩平，掌心斜向上，右手收至右胯旁，掌心向下，目視左手。（圖 2-11）

Continue to turn left, the center of gravity moves to the left, left foot bow step forward, right foot pushes back into left bow stance, at the same time open both arms in an oblique direction, left wrist and shoulder flat, palm oblique upwards, press right hand to the right hip, palm down, look at the left hand. (Fig. 2-11)

3

第三式 白鶴亮翅
White Crane Spreads its Wings

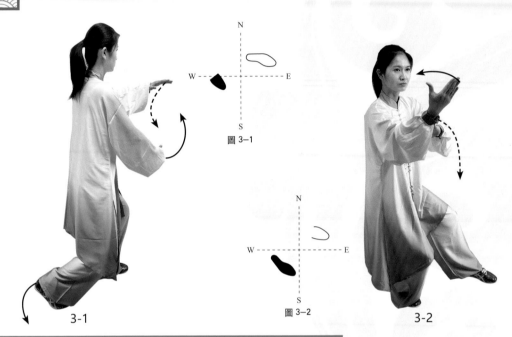

圖 3-1

圖 3-2

3-1

3-2

1、收腳抱球 Withdraw foot and hold ball

身體左轉，右腳收至左腳右後側，腳尖著地，同時兩掌相抱至左胸前，左掌在上，掌心向下，右掌在下，掌心向上，目視左手。（圖 3-1）

Turn left, withdraw the right foot to the right rear side of the left foot, point the toes to the ground, while the two palms face one another in front of the left chest. Left palm is on the top, facing down, right palm is on the bottom, facing up look at the left hand. (Fig. 3-1)

2、坐腿合舉 Sit back and raise palms

身體右轉，重心右移，右腳踩實，左腳腳跟上提，同時兩臂相合向右、向上掤舉，目視右手。（圖 3-2）

Turn right, the center of gravity moves to the right, the right foot treads firmly, the left heel lifts upwards, at the same time the two arms come together and move to the right, lift upwards, look at the right hand. (Fig. 3-2)

第三式 白鶴亮翅
White Crane Spreads its Wings

3

3、虛步分掌 Empty step and open palms

身體左轉，左腳輕輕提起再以腳掌點地，成虛步，同時兩手上下斜分，右手至頭部右前側，掌心向左後方，左手落於左胯前，掌心向下，目視前方。（圖 3-3）

Turn left, the left foot gently lifts and then the sole of the foot points to the ground to form an empty stance. At the same time both arms part as they move up and down in an oblique direction, right hand to the right side and in front of the forehead, palm to the left rear, left hand to the left hip, palm down and look straight ahead. (Fig. 3-3)

3-3

圖 3-3

3-3 正面示範

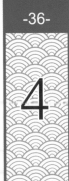

4

第四式 左右摟膝拗步
Brush Knee and Twist Step on Both Sides

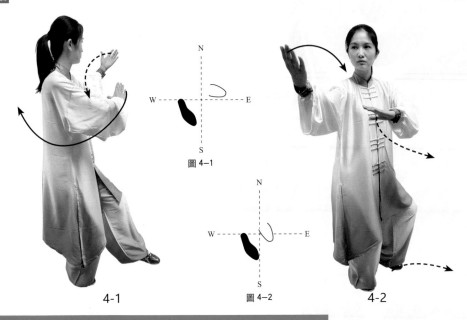

4-1

圖 4—1

圖 4—2

4-2

1、左轉翻掌 Turn left and turn over palm

身體左轉，右手向左、向下劃弧翻掌下落，掌心向下，左掌外旋，掌心向上，目視右手。（圖 4-1）

Turn left, the right hand to the left, move it downwards in an arc, palm downwards, left palm rotates externally, palm upwards, look at the right hand. (Fig. 4-1)

2、右轉舉掌 Turn right and raise palm

身體右轉，左掌內旋 掌心向下，右掌外旋，掌心向上，同時左腳收至右腳內側，腳尖著地，目視右手。（圖 4-2）

Turn right, left palm rotates internally, palm downwards, right palm rotates externally with the palm facing upwards, while the left foot steps to the inside of the right foot, the sole of the foot points to the ground, look at the left hand. (Fig. 4-2)

第四式 左右摟膝拗步
Brush Knee and Twist Step
on Both Sides

4

3、上步屈肘 Step forward and bend elbow

身體左轉，左腳向左前方上步，同時右手屈肘收至右耳側，掌心斜向前，左手下落在胸前，掌心向下，目視前方。（圖 4-3）

Turn left, step the left foot to the front left, while the right hand bends at the elbow to the side of the right ear, the palm oblique forwards, the left hand falls in front of the chest, the palm is down, look straight ahead. (Fig. 4-3)

4、弓步摟推 Bow step and push palm

身體繼續左轉，左腳前弓，右腳後蹬，成左弓步，同時右掌經右耳側向前推出，腕與肩平，力達掌根，左掌經左膝前摟至左胯旁，掌心向下，目視右手。（圖 4-4）

Continue to turn left, left foot bow step forward, right foot pushes back into left bow stance, while the right palm moves forward alongside the right ear, wrist and shoulder flat, with force at the palm root, brush left palm from the left knee to the left hip, palm down, look at the right hand. (Fig. 4-4)

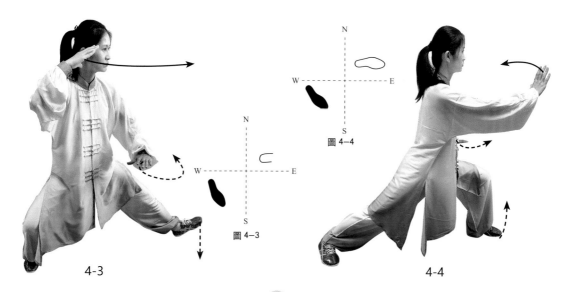

圖 4-3

圖 4-4

4-3

4-4

4 第四式 左右摟膝拗步
Brush Knee and Twist Step on Both Sides

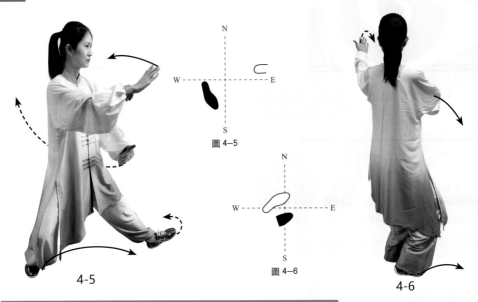

圖 4-5

圖 4-6

4-5

4-6

5、後坐翻掌 Sit back and turn over palm

身體右轉，重心右移，左掌外旋翻掌，收至腹前，掌心向上，目視右手。（圖 4-5）

Turn right, the center of gravity moves to the right, the left palm rotates externally and retracts to the abdomen front, the palm is upwards, look at the right hand. (Fig. 4-5)

6、收腳舉掌 Withdraw foot and raise palm

身體左轉，重心左移，左手劃弧上舉至左肩後側，腕與肩平，掌心斜向上，右手收至左胸前，掌心向下，同時右腳收至左腳內側，腳尖著地，目視左手。（圖 4-6）

Turn left, the center of gravity moves to the left, the left hand is raised to the rear side of the left shoulder, the wrist is level with the shoulder, the palm faces upwards in an oblique direction, the right hand comes to the left chest, the palm faces downwards, while the right foot retracts to the inside of the left foot, the sole of the foot points to the ground, look at the left hand. (Fig. 4-6)

第四式 左右摟膝拗步
Brush Knee and Twist Step on Both Sides

7、上步屈肘 Step forward and bend elbow

身體右轉，右腳向右前方上步，同時左手屈肘收至左耳側，掌心斜向前，右手下落在胸前，掌心向下，目視右腳。（圖4-7）

Turn right, step the right foot to the front right, while the left hand bends at the elbow to the side of the left ear, the palm oblique forward, the right hand falls in front of the chest, the palm is down, look at the right foot. (Fig. 4-7)

8、弓步摟推 Bow step and push palm

身體繼續右轉，右腳前弓，左腳後蹬，成右弓步，同時左掌經左耳側向前推出，腕與肩平，力達掌根，右掌經右膝前摟至右胯旁，掌心向下，目視左手。（圖4-8）

Continue to turn right, right foot bow step forward, left foot pushes back into right bow stance, while the left palm moves forward alongside the left ear, wrist and shoulder flat, with force at the palm root, brush right palm from the right knee to the right hip, palm down, look at the left hand. (Fig. 4-8)

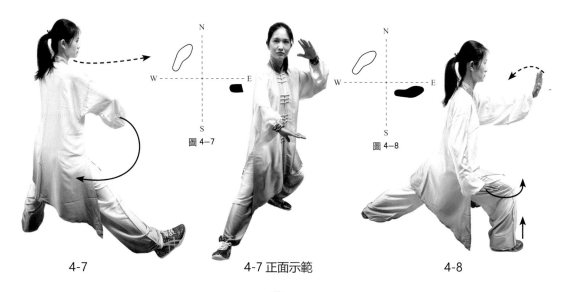

圖4-7　　　　　圖4-8

4-7　　　　　4-7 正面示範　　　　　4-8

4 第四式 左右摟膝拗步
Brush Knee and Twist Step on Both Sides

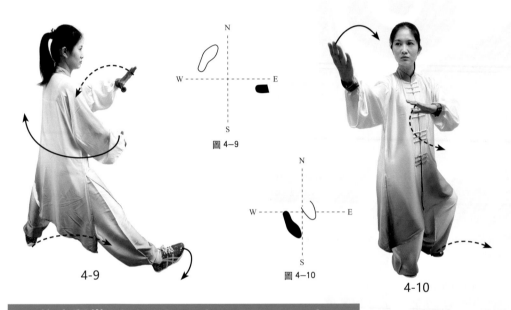

圖 4-9

4-9

圖 4-10

4-10

9、後坐翻掌 Sit back and turn over palm

身體左轉，重心左移，右掌外旋翻掌，收至腹前，掌心向上，目視左手。（圖 4-9）

Turn left, the center of gravity moves to the left, the right palm rotates externally and retracts to the abdomen front, the palm is upwards, look at the left hand. (Fig. 4-9)

10、右轉舉掌 Turn right and raise palm

身體右轉，左掌內旋 掌心向下，右掌外旋，掌心向上，同時左腳收至右腳內側，腳尖著地，目視右手。（圖 4-10）

Turn right, left palm rotates internally, palm downwards, right palm rotates externally with the palm facing upwards, while the left foot steps to the inside of the right foot, the sole of the foot points to the ground, look at the left hand. (Fig. 4-10)

第四式 左右摟膝拗步
Brush Knee and Twist Step on Both Sides

4

11、上步屈肘 Step forward and bend elbow

身體左轉，左腳向左前方上步，同時右手屈肘收至右耳側，掌心斜向前，左手下落在胸前，掌心向下，目視前方。（圖 4-11）

Turn left, step the left foot to the front left, while the right hand bends at the elbow to the side of the right ear, the palm oblique forward, the left hand falls in front of the chest, the palm is down, look straight ahead. (Fig. 4-11)

12、弓步摟推 Bow step and push palm

身體繼續左轉，左腳前弓，右腳後蹬，成左弓步，同時右掌經右耳側向前推出，腕與肩平，力達掌根，左掌經左膝前摟至左胯旁，掌心向下，目視右手。（圖 4-12）

Continue to turn left, left foot bow step forward, right foot pushes back into left bow stance, while the right palm moves forward alongside the right ear, wrist and shoulder flat, with force at the palm root, brush left palm from the left knee to the left hip, palm down, look at the right hand. (Fig. 4-12)

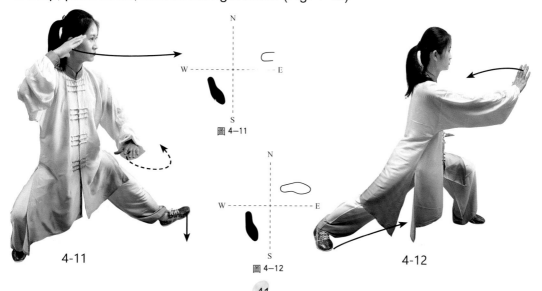

圖 4-11

圖 4-12

4-11

4-12

第五式 手揮琵琶
Strumming the Lute

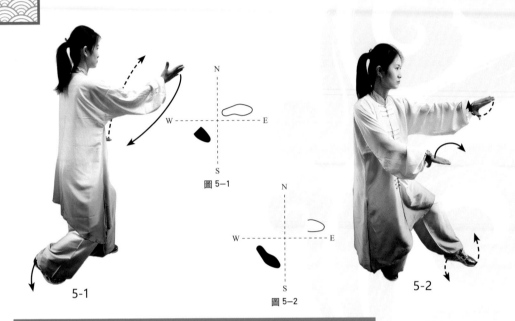

圖 5-1

5-1

圖 5-2

5-2

1、收腳擺掌 Withdraw foot and swing palm

身體左轉，右腳收至左腳右後側，腳尖著地，同時右手向左平擺，掌心向上，左掌隨轉腰向左移至左胯旁，掌心向下，目視右手。（圖 5-1）

Turn left, the right foot retracts to the right rear side of the left foot, the sole of the foot points to the ground, at the same time swing the right hand to the left, palm upwards, the left palm moves to the left hip with the turn waist, palm downwards, look at the right hand. (Fig. 5-1)

2、右轉帶臂 Turn right and bring arm

身體右轉，重心右移，同時右掌內旋收至右胯旁，掌心向下，左臂向右平帶，掌心斜向下，目視左手。（圖 5-2）

Turn right, the center of gravity moves to the right, at the same time the right palm rotates internally to the right hip, palm downwards, the left arm remains level while moving to the right, palm oblique downwards, look at the left hand. (Fig. 5-2)

第五式 手揮琵琶 5

Strumming the Lute

3、虛步合臂 Empty step and bring arms together

身體繼續右轉，再微左轉，左腳提起再以腳跟著地，左膝微屈，成虛步，同時兩臂外旋，右掌在左肘內下側，掌心向左，左掌在上，腕與肩平，掌心向右，目視左手。（圖 5-3）

Continue to turn right, then slightly left, lift left foot and then heel to the ground, left knee flexes slightly into an empty stance, at the same time two arms rotate externally, right palm rests beside the internal and lower side of the left elbow, palm to left, left palm on top, wrist and shoulder flat, palm to the right, look at the left hand. (Fig. 5-3)

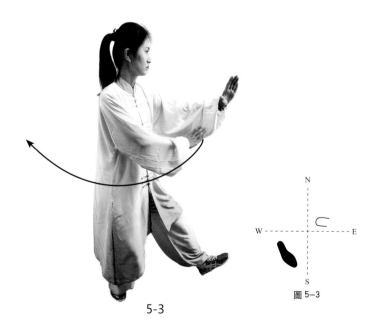

5-3

圖 5-3

6

第六式 倒卷肱
Repulse Monkey

1、右轉舉掌 Turn right and raise palm

身體右轉，右掌外旋向右、向後、向上劃弧至右肩後側，掌心向上，目視右手。（圖 6-1）

Turn right, the right palm rotates externally to the right and backwards, then upwards in an arc to the rear side of the right shoulder, palm upwards, look at the right hand. (Fig. 6-1)

2、撤步翻掌 Step backward and turn over palm

身體左轉，提左腳經右腳內側向左後方撤步，腳尖點地，同時右臂屈肘收至右耳側，掌心斜向前，左掌外旋翻掌，掌心向上，目視左手。（圖 6-2）

Turn left, lift left foot through the inside of the right foot to the left back step, point the toes to the ground, while the right arm bends the elbow to the side of the right ear, palm oblique forward, left palm rotates externally, palm upwards, look at the left hand. (Fig. 6-2)

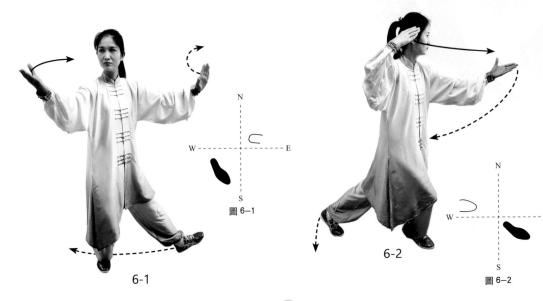

6-1 　　　　圖 6-1

6-2 　　　　圖 6-2

第六式 倒卷肱

Repulse Monkey

6

6-3

6-3 正面示範

圖 6-3、6-4

6-4

3、虛步推掌 Empty step and push palm

身體繼續左轉，重心左移，右腳跟提起變右虛步，同時右掌經右耳側向前推出，力達掌根，腕與肩平，左掌回收至左腰側，掌心向上，目視右手。（圖 6-3）

Continue to turn left, the center of gravity moves to the left, the right heel lifts and change into right empty stance. At the same time the right palm pushes forward alongside the right ear, the force reaches the palm root, the wrist and the shoulder level, retract the left palm to the left waist, palm upwards, look at the right hand. (Fig. 6-3)

4、左轉舉掌 Turn left and raise palm

身體左轉，左掌外旋向左、向後、向上劃弧至左肩後側，掌心向上，目視左手。（圖 6-4）

Turn left, the left palm rotates externally to the left and backwards, then upwards in an arc to the rear side of the left shoulder, palm upwards, look at the left hand. (Fig. 6-4).

6

第六式 倒卷肱
Repulse Monkey

5、撤步翻掌 Step backward and turn over palm

身體右轉，提右腳經左腳內側向右後方撤步，腳尖點地，同時左臂屈肘收至左耳側，掌心斜向前，右掌外旋翻掌，掌心向上，目視右手。（圖 6-5）

Turn right, lift right foot through the inside of the left foot to the right back step, point the toes to the ground, while the left arm bends the elbow to the side of the left ear, palm oblique forward, right palm rotates externally, palm upwards, look at the right hand. (Fig. 6-5)

6、虛步推掌 Empty step and push palm

身體繼續右轉，重心右移，左腳跟提起變左虛步，同時左掌經左耳側向前推出，力達掌根，腕與肩平，右掌回收至右腰側，掌心向上，目視左手。（圖 6-6）

Continue to turn right, the center of gravity moves to the right, the left heel lifts and change into left empty stance. At the same time the left palm pushes forward alongside the left ear, the force reaches the palm root, the wrist and the shoulder level, retract the right palm to the right waist, palm upwards, look at the left hand. (Fig. 6-6)

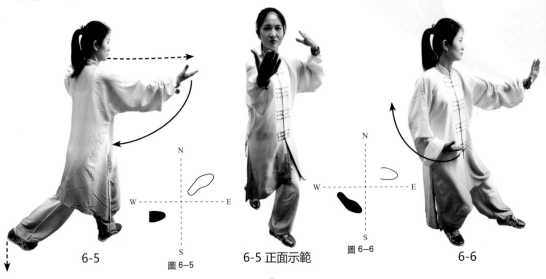

6-5　　　圖 6-5　　　6-5 正面示範　　　圖 6-6　　　6-6

第六式 倒卷肱
Repulse Monkey

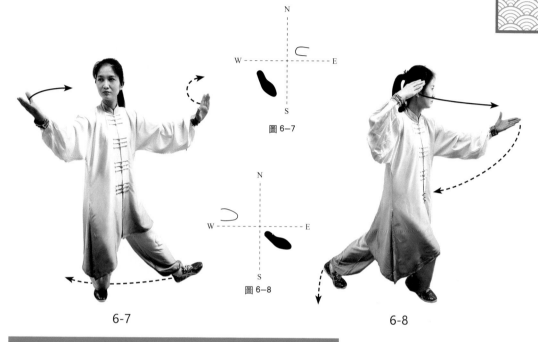

圖 6-7

圖 6-8

6-7

6-8

7、右轉舉掌 Turn right and raise palm

身體右轉，右掌外旋向右、向後、向上劃弧至右肩後側，掌心向上，目視右手。（圖 6-7）

Turn right, the right palm rotates externally to the right and backwards, then upwards in an arc to the rear side of the right shoulder, palm upwards, look at the right hand. (Fig. 6-7)

8、撤步翻掌 Step backward turn over palm

身體左轉，提左腳經右腳內側向左後方撤步，腳尖點地，同時右臂屈肘收至右耳側，掌心斜向前，左掌外旋翻掌，掌心向上，目視左手。（圖 6-8）

Turn left, lift left foot through the inside of the right foot to the left back step, point the toes to the ground, while the right arm bends the elbow to the side of the right ear, palm oblique forward, left palm rotates externally, palm upwards, look at the left hand. (Fig. 6-8)

第六式 倒卷肱
Repulse Monkey

9、虛步推掌 Empty step and push palm

身體繼續左轉，重心左移，右腳跟提起變右虛步，同時右掌經右耳側向前推出，力達掌根，腕與肩平，左掌回收至左腰側，掌心向上，目視右手。（圖6-9）

Continue to turn left, the center of gravity moves left, the right heel lifts and change into right empty stance. At the same time the right palm pushes forward alongside the right ear, the force reaches the palm root, the wrist and the shoulder level, retract the left palm to the left waist, palm upwards, look at the right hand. (Fig. 6-9)

10、左轉舉掌 Turn left and raise palm

身體左轉，左掌外旋向左、向後、向上劃弧至左肩後側，掌心向上，目視左手。（圖6-10）

Turn left, the left palm rotates externally to the left and backwards, then upwards in an arc to the rear side of the left shoulder, palm upwards, look at the left hand. (Fig. 6-10)

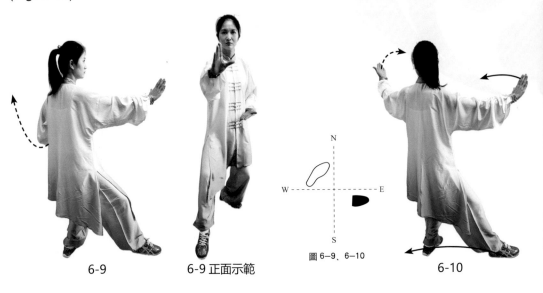

6-9　　　　　6-9 正面示範　　　　　圖 6-9、6-10　　　　　6-10

第六式 倒卷肱
Repulse Monkey

6

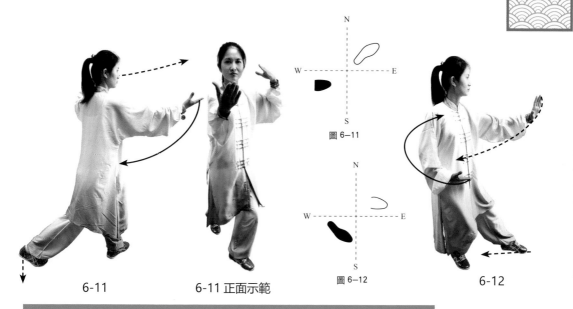

6-11　　　　　6-11 正面示範　　　　圖 6-11　圖 6-12　　　　6-12

11、撤步翻掌 Step backward and turn over palm

身體右轉，提右腳經左腳內側向右後方撤步，腳尖點地，同時左臂屈肘收至左耳側，掌心斜向前，右掌外旋翻掌，掌心向上，目視右手。（圖 6-11）

Turn right, lift right foot through the inside of the left foot to the right back step, point the toes to the ground, while the left arm bends the elbow to the side of the left ear, palm oblique forward, right palm rotates externally, palm upwards, look at the right hand. (Fig. 6-11)

12、虛步推掌 Empty step and push palm

身體繼續右轉，重心右移，左腳跟提起變左虛步，同時左掌經左耳側向前推出，力達掌根，腕與肩平，右掌回收至右腰側，掌心向上，目視左手。（圖 6-12）

Continue to turn right, the center of gravity moves to the right, the left heel lifts and change into left empty stance. At the same time the left palm pushes forward alongside the left ear, the force reaches the palm root, the wrist and the shoulder level, retract the right palm to the right waist, palm upwards, look at the left hand. (Fig. 6-12).

7 第七式 左攬雀尾
Grasp the Bird's Tail (Left)

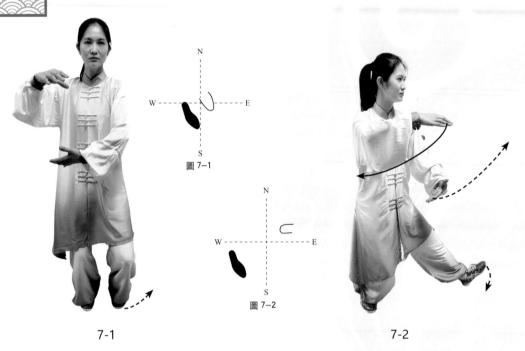

7-1 圖 7-1 圖 7-2 7-2

1、收腳抱球 Withdraw foot and hold ball

身體右轉，收左腳至右腳內側，腳尖點地，同時右掌劃弧平屈在右胸前，掌心向下，左掌劃弧收至右肋前，掌心向上，目視右手。（圖 7-1）

Turn right, retract left foot to the inside of right foot, point the toes to the ground, at the same time the right palm draws an arc and rest in front of the right chest, palm downwards, left palm draws an arc to front of the right rib cage, palm upwards, look at the right hand. (Fig. 7-1)

2、左轉上步 Turn left and step forward

身體左轉，左腳向左前方上步，腳跟著地，目視左前方。（圖 7-2）

Turns left, the left foot moves up to the front left, heel to the ground, look front left. (Fig. 7-2)

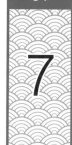

第七式 左攬雀尾
Grasp the Bird's Tail (Left)

3、弓步左掤 Bow step and left ward-off

身體繼續左轉，左腳前弓，右腳後蹬，成左弓步，同時左臂向前掤出，腕與肩平，掌心向內，右手下落至右胯旁，掌心向下，目視前方。（圖 7-3）

Continue to turn left, left foot bow step forward, right foot pushes back into left bow stance, while the left arm push out forward, wrist and shoulder flat, palm inwards, right hand fall to the right hip, palm down, look straight ahead. (Fig. 7-3)

4、左轉伸掌 Turn left and extend arms forward

身體繼續左轉，兩掌隨轉腰向左前伸，左掌內旋，掌心向下，右掌外旋，掌心向上，目視左手。（圖 7-4）

Continue to turn left, two arms follow the turn of the waist to extend forward to the left side, left palm rotates internally, palm down, right palm rotate externally, palm upwards, look at the left hand. (Fig. 7-4)

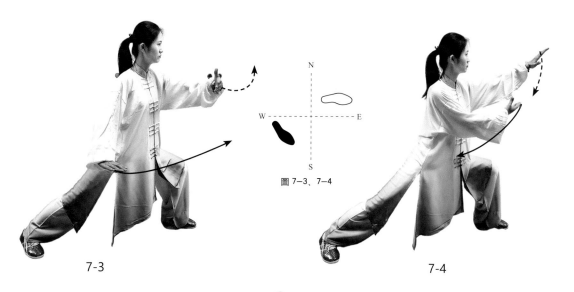

圖 7-3、7-4

7-3

7-4

7

第七式 左攬雀尾
Grasp the Bird's Tail (Left)

5、右轉下捋 Turn right and rollback downwards

身體右轉，重心右移，兩手向右、向下捋至腹前，左掌掌心向下，右掌掌心向上，目視左手。（圖 7-5）

Turn right, the center of gravity moves to the right, hands rollback downwards to the right, in front of the abdomen, left palm downwards, right palm upwards, look at the left hand. (Fig. 7-5)

6、右轉翻掌 Turn right and turn over palms

身體繼續右轉，右手劃弧至右肩後側，腕與肩平，掌心向上，左手屈臂收至胸前，掌心向內，目視右手。（圖 7-6）

Continue to turn right, the right hand is drawn to the rear side of the right shoulder, the wrist is level with the shoulder, palm upwards, bends the left arm to the chest, palm inwards, look at the right hand. (Fig. 7-6)

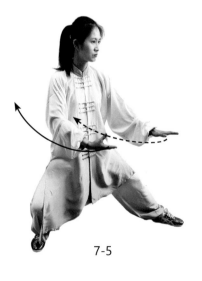

7-5

圖 7-5、7-6

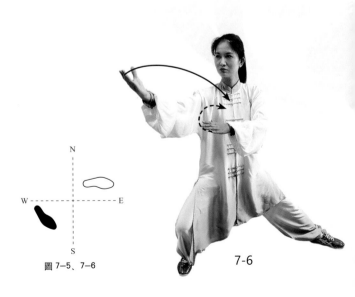

7-6

第七式 左攬雀尾
Grasp the Bird's Tail (Left)

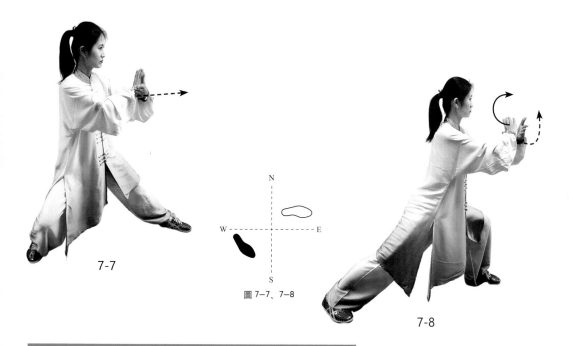

7-7

圖 7-7、7-8

7-8

7、左轉搭腕 Turns left and cross wrist

身體左轉，右臂屈肘回收搭於左手腕內側，掌心相對，目視前方。（圖 7-7）

Turn left, bends right arm and retracts onto the left wrist, palms facing one another, look straight ahead. (Fig. 7-7)

8、弓步前擠 Bow step and push forward

身體繼續左轉，左腳前弓，右腳後蹬，成左弓步，同時兩臂圓撐向前擠出，力達左前臂外側，目視前方。（圖 7-8）

Continue to turn left, left foot bow step forward, right foot pushes back into the left bow stance, while the two arms form a circular brace and push forward, the force reaches the outside of the left forearm, look straight ahead. (Fig. 7-8)

7

第七式 左攬雀尾
Grasp the Bird's Tail (Left)

9、抹掌平分 Spread the palms apart

兩掌平抹分開，肩高肩寬，兩掌掌心均向下，目視前方。（圖 7-9）

Spread the palms apart to the height and width of the shoulders, both palms downwards, look straight ahead. (Fig. 7-9)

10、後坐下按 Sit back and press downwards

身體微右轉，重心右移，左腳尖上翹，兩掌隨後坐向後弧線回收再下按，掌心向下，目視前方。（圖 7-10）

Turn slightly to the right, the center of gravity moves to the right, raise the left tiptoes up, sit back, the two palms then retract in an arc and press down, palms down, look straight ahead. (Fig. 7-10)

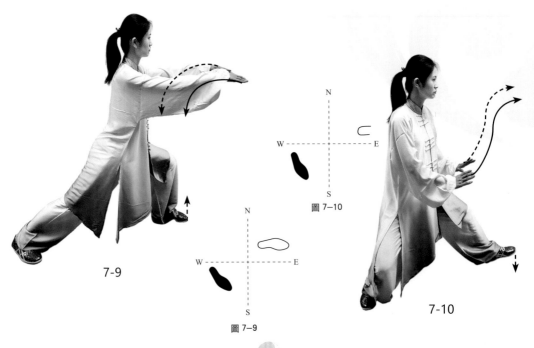

7-9

圖 7-9

圖 7-10

7-10

第七式 左攬雀尾
Grasp the Bird's Tail (Left)

7

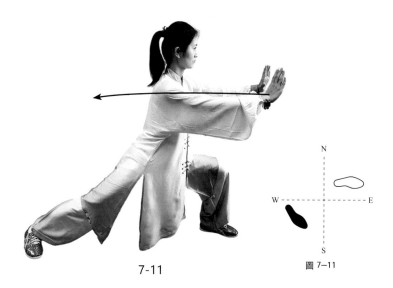

7-11

圖 7-11

11、弓步前按 Bow step and press forward

身體左轉，左腳前弓，右腳後蹬，成左弓步，同時兩掌自下向上再向前按出，腕於肩平，力達掌根，目視前方。（圖 7-11）

Turn left, left foot bow step forward, right foot pushes back into the left bow stance, at the same time two palms press up and forward, wrists level with shoulders, the force reaches the palm root, look straight ahead. (Fig. 7-11)

第八式 右攬雀尾
Grasp the Bird's Tail (Right)

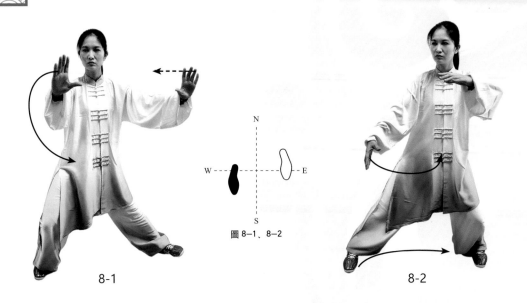

圖 8–1、8–2

8-1 8-2

1、右轉分掌 Turns right and open palm

身體右轉，重心右移，左腳上翹微內扣，右臂向右平移分開，目視右手。（圖 8-1）

Turn right, the center of gravity moves to the right, the left foot upturns and slightly internally rotates, the right arm moves to the right to separate, look at the right hand. (Fig. 8-1)

2、收腳抱球 Withdraw foot and hold ball

身體左轉，收右腳至左腳內側，腳尖點地，同時左掌平屈在左胸前，掌心向下，右掌劃弧收至左肋前，掌心向上，目視左手。（圖 8-2）

Turn left, retract the right foot to the inside of the left foot, point the toes to the ground, while the left forearm rests in front of the left chest, palm downwards, right palm moves in an arc and rest in front of the left rib, palm upwards, look at the left hand. (Fig. 8-2)

第八式 右攬雀尾 8
Grasp the Bird's Tail (Right)

3、右轉上步 Turn right and step forward

身體右轉，右腳向右前方上步，腳跟著地，目視右前方。（圖 8-3）

Turn right, the right foot moves up to the front right, heel to the ground, look straight ahead. (Fig. 8-3)

4、弓步右掤 Bow step and right ward-off

身體繼續右轉，右腳前弓，左腳後蹬，成右弓步，同時右臂平屈向前掤出，腕與肩平，掌心向內，左手下落至左胯旁，掌心向下。（圖 8-4）

Continue to turn right, the right foot bow step forward, left foot pushes back into right bow stance, while the right arm forward pushes out, wrist and shoulder level, palm inward, left hand fall to the left hip, palm down, look straight ahead. (Fig. 8-4)

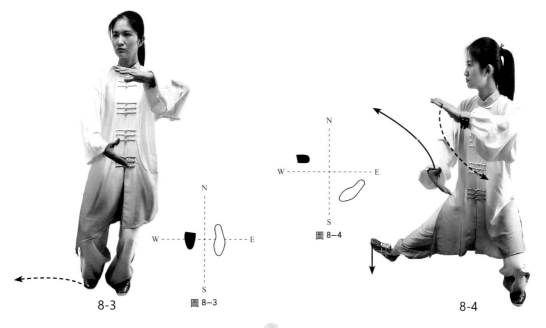

8-3　　　圖 8-3　　　圖 8-4　　　8-4

8

第八式 右攬雀尾
Grasp the Bird's Tail (Right)

5、右轉伸掌 Turn right and extend arms forward

身體繼續右轉，兩掌隨轉腰向右前伸，右掌內旋，掌心向下，左掌外旋，掌心向上，目視右手。（圖 8-5）

Continue to turn right, two palms follow the turn of the waist to extend forward to the right side, right palm rotates internally, palm down, left palm rotate externally, palm upwards, look at the left hand. (Fig. 8-5)

6、左轉下将 Turn left and rollback downwards

身體左轉，重心左移，兩手向左、向下将至腹前，右掌掌心向下，左掌掌心向上，目視右手。（圖 8-6）

Turn left, the center of gravity moves to the left, hands rollback downwards to the left, in front of the abdomen, right palm downwards, left palm upwards, look at the right hand. (Fig. 8-6)

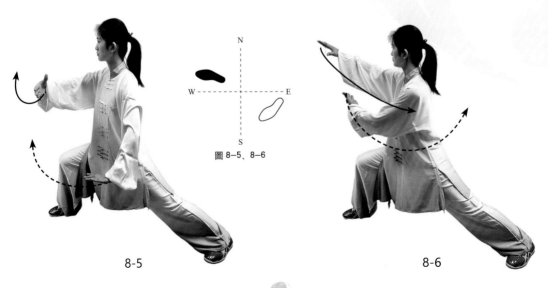

圖 8-5、8-6

8-5 8-6

第八式 右攬雀尾
Grasp the Bird's Tail (Right)

8

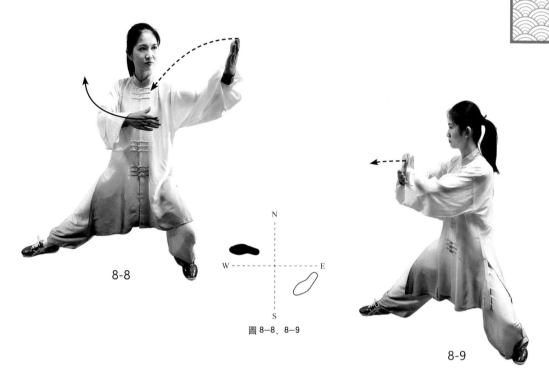

8-8

8-9

圖 8-8、8-9

7、左轉翻掌 Turn left and turn over palms

身體繼續左轉，左手劃弧至左肩後側，腕與肩平，掌心向上，右手屈臂收至胸前，掌心向內，目視左手。（圖 8-8）

Continue to turn left, the left hand is drawn to the rear side of the left shoulder, the wrist is level with the shoulder, palm upwards, bends the right arm to the chest, palm inwards, look at the left hand. (Fig. 8-8)

8、右轉搭腕 Turns left and cross wrists

身體右轉，左臂屈肘回收搭於右手腕內側，掌心相對，目視前方。（圖 8-9）

Turn right, bends left arm and retracts onto the right wrist, palms facing one another, look straight ahead. (Fig. 8-9)

第八式 右攬雀尾
Grasp the Bird's Tail (Right)

9、弓步前擠 Bow step and push forward

身體繼續右轉，右腳前弓，左腳後蹬，成右弓步，同時兩臂圓撐向前擠出，力達右前臂外側，目視前方。（圖 8-10）

Continue to turn right, the right foot bow step forward, left foot pushes back into the right bow stance, while the two arms form a circular brace and push forward, the force reaches the outside of the right forearm, look straight ahead. (Fig. 8-10)

10、抹掌平分 Spread the palms apart

兩掌平抹分開，肩高肩寬，兩掌掌心均向下，目視前方。（圖 8-11）

Spread the palms apart to the height and width of the shoulders, both palms downwards, look straight ahead. (Fig. 8-11)

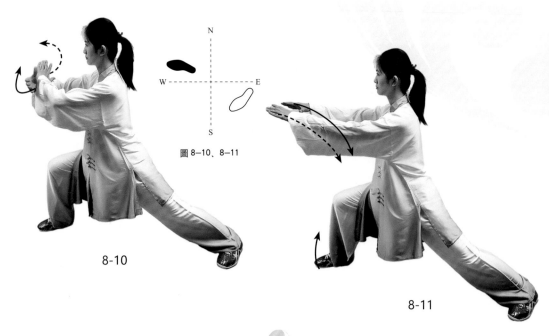

圖 8—10、8—11

8-10

8-11

第八式 右攬雀尾
Grasp the Bird's Tail (Right)

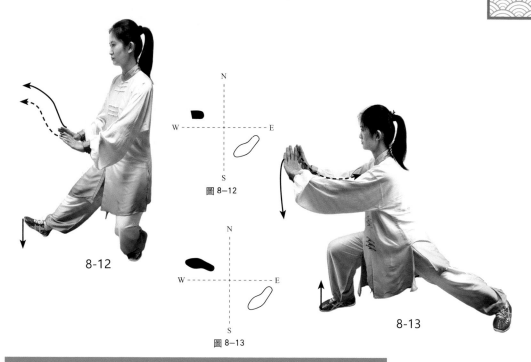

圖 8-12

8-12

8-13

圖 8-13

11、後坐下按 Sit back and press downwards

身體微左轉，重心左移，右腳尖上翹，兩掌隨後坐向後弧線回收再下按，掌心向下，目視前方。（圖 8-12）

Turn slightly to the left, the center of gravity moves to the left, raise the right tiptoes up, sit back, the two palms then retract in an arc and press down, palms down, look straight ahead. (Fig. 8-12)

12、弓步前按 Bow step and press forward

身體右轉，右腳前弓，左腳後蹬，成右弓步，同時兩掌自下向上再向前按出，腕於肩平，力達掌根，目視前方。（圖 8-13）

Turn right, right foot bow step forward, left foot pushes back into the right bow stance, at the same time two palms press up and forward, wrist level with shoulders, the force reaches the palm root, look straight ahead. (Fig. 8-13)

9 第九式 單鞭
Single Whip

9-1　9-2　9-3

圖 9-1、9-2、9-3

1、左轉雲掌 Turn left and cloud hands

身體左轉，重心左移，右腳內扣，同時左手以腰為軸向左雲掌，掌心向外，右手劃弧向左、向下雲掌，掌心向內，目視左手。（圖 9-1、9-2）

Turn left, the center of gravity moves to the left, the right foot rotates internally, at the same time takes the waist as the axial, left cloud hand, left palm outwards, the right hand draws an arc to the left, down cloud hand, right palm inwards, look at the left hand. (Fig. 9-1、9-2)

2、右轉雲掌 Turn right and cloud hands

身體右轉，重心右移，同時右掌劃弧向右、向上雲掌，腕與肩平，掌心向內，左掌劃弧收至腹前，掌心向內，目視右手。（圖 9-3）

Turn right, the center of gravity moves to the right, while the right palm strokes towards the right in an upwards cloud hand, wrist and shoulder level, palm inwards, left palm draws an arc to the front of the abdomen, palm inward, look at right hand. (Fig. 9-3)

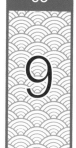

第九式 單鞭
Single Whip
9

3、丁步按掌 T step and press arm

身體右轉，左腳收至右腳內側，腳尖點地，同時右手外翻按掌，腕與肩平，掌心向外，左掌收至右手腕部內側，掌心向內，目視右手。（圖 9-4）

Turn right, the left foot retracts to the inside of the right foot, point the toes to the ground, at the same time turn the right hand over, the force reaches the palm root, the wrist and shoulder level, palms outwards, retracts the left palm to the inside of the right wrist, palm inwards, look at the right hand. (Fig. 9-4)

4、勾手上步 Hook hand and step forward

身體左轉，右掌變勾手，左手向左平移，掌心向內，同時左腳向左上步，腳跟著地，目視左手。（圖 9-5）

Turn left, the right palm changes into hook hand, the left hand moves to the left, palm inwards, at the same time the left foot step forward to the left, heel to the ground, look at the left hand. (Fig. 9-5)

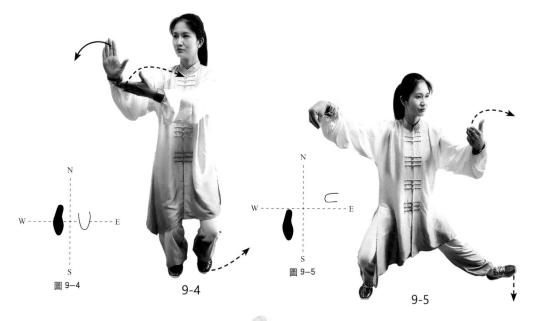

圖 9-4

9-4

圖 9-5

9-5

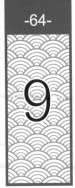

第九式 單鞭
Single Whip

5、弓步推掌 Bow step and push palm

身體繼續左轉，左腳前弓，右腳後蹬，成左弓步，同時左手向左、向前翻掌前推，腕與肩平，力達掌根，右手保持勾手不變，目視左手。（圖 9-6）

Continue to turn left, left foot bow step forward, right foot pushes back into left bow stance, at the same time flip the left hand and push to the front left, wrist and shoulder level, the force reaches the palm root, right hand keep as a hook, look at the left hand. (Fig. 9-6)

9-6

圖 9-6

第十式 雲手
Cloud Hands

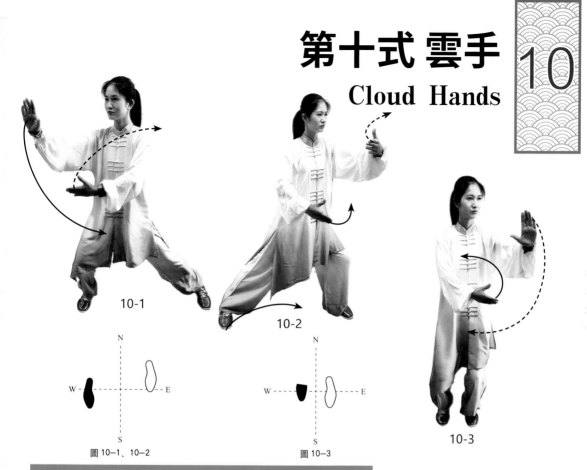

10-1

10-2

10-3

圖 10-1、10-2

圖 10-3

1、右轉雲掌 Turn right and cloud hands

身體右轉，重心右移，同時左掌劃弧向右、向下雲掌，掌心向內，右勾手變掌，掌心向外，目視右手。（圖 10-1）

Turn right, the center of gravity moves to the right, at the same time, the left palm draws an arc to the right and downwards cloud hand, palm inwards, release right hook hand to palm, palm outwards, look at the right hand. (Fig. 10-1)

2、收腳雲掌 Close foot and cloud hands

身體左轉，右腳收至左腳內側，腳尖點地，同時左手向左雲掌，腕與肩平，掌心向外，右手雲掌至左肋旁，掌心向內，目視左手。（圖 10-2、10-3）

Turn left, the right foot retracts to the inside of the left foot, point the toes to the ground, while the left hand performs the left cloud hand, wrist and shoulder level, palm outwards, right hand cloud hand to the left side of the rib, palm inwards, look at the left hand. (Fig. 10-2、10-3)

10

第十式 雲手
Cloud Hands

3、開步雲掌 Open step and cloud hands

身體右轉，左腳向左橫開一步，腳尖點地，同時右手向右雲掌，腕與肩平，掌心向外，左手雲掌至左肋旁，掌心向內，目視右手。（圖 10-4、10-5）

Turn right, the left foot takes one horizontal step to the left, point the toes to the ground, while the right hand performs the right cloud hand, wrist and shoulder level, palm faces outwards, left hand cloud hand to the left rib, palm inwards, look at the right hand. (Fig. 10-4、10-5)

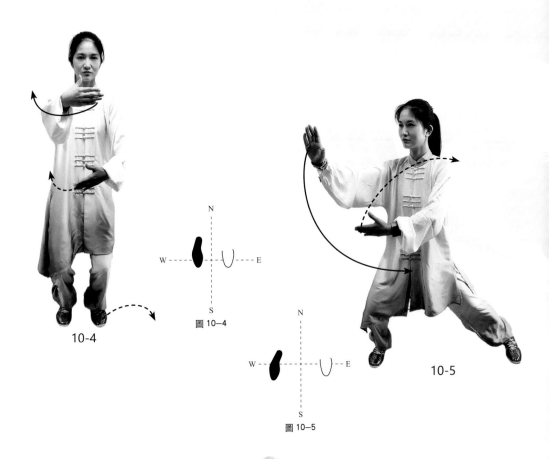

10-4

圖 10—4

圖 10—5

10-5

第十式 雲手
Cloud Hands

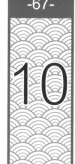

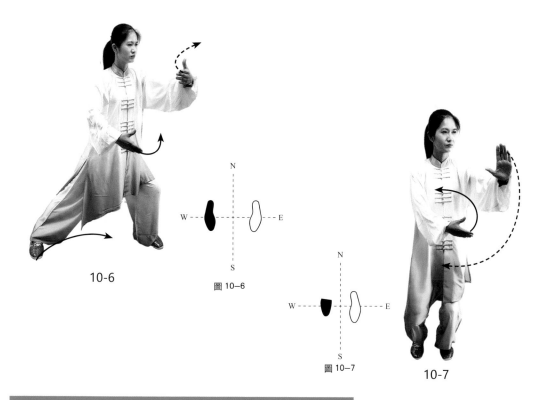

10-6

圖 10-6

圖 10-7

10-7

4、收腳雲掌 Close foot and cloud hands

身體左轉，右腳收至左腳內側，腳尖點地，同時左手向左雲掌，腕與肩平，掌心向外，右手雲掌至左肋旁，掌心向內，目視左手。（圖 10-6、10-7）

Turn left, the right foot retracts to the inside of the left foot, point the toes to the ground while the left hand performs the left cloud hand, wrist and shoulder level, palm outwards, right hand cloud hand to the left side of the rib, palm inwards, look at the left hand. (Fig. 10-6、10-7)

10

第十式 雲手
Cloud Hands

5、開步雲掌 Open step and cloud hands

身體右轉，左腳向左橫開一步，腳尖點地，同時右手向右雲掌，腕與肩平，掌心向外，左手雲掌至左肋旁，掌心向內，目視右手。（圖 10-8、10-9）

Turn right, the left foot takes one horizontal step to the left, point the toes to the ground, while the right hand performs the right cloud hand, wrist and shoulder level, palm faces outward, left hand cloud hand to the left rib, palm inwards, look at the right hand. (Fig. 10-8、10-9)

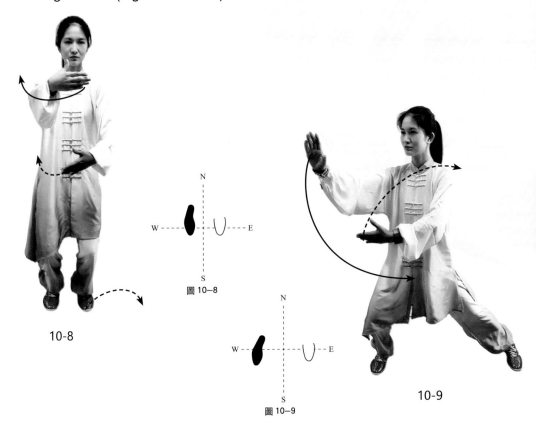

10-8

圖 10—8

圖 10—9

10-9

第十式 雲手
Cloud Hands

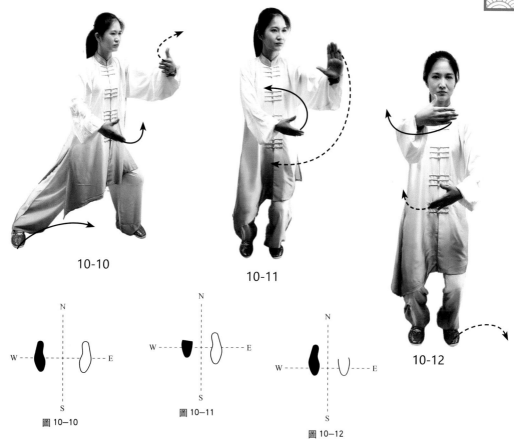

10-10

10-11

10-12

圖 10—10

圖 10—11

圖 10—12

6、收腳雲掌 Close foot and cloud hands

身體左轉，右腳收至左腳內側，腳尖點地，同時左手向左雲掌，腕與肩平，掌心向外，右手雲掌至左肋旁，掌心向內，目視左手。（圖 10-10、10-11、10-12）

Turn left, the right foot retracts to the inside of the left foot, point the toes to the ground while the left hand performs the left cloud hand, wrist and shoulder level, palm outwards, right hand cloud hand to the left side of the rib, palm inward, look at the left hand. (Fig. 10-10、10-11、10-12)

第十一式 單鞭
Single Whip

1、丁步按掌 T step and press arm

身體右轉，左腳收至右腳內側，腳尖點地，同時右手外翻按掌，腕與肩平，掌心向外，左掌收至右手腕部內側，掌心向內，目視右手。（圖 11-1）

Turn right, the left foot retracts to the inside of the right foot, point the toes to the ground, at the same time turn the right hand over, the force reaches the palm root, the wrist and shoulder level, palm outwards, retracts the left palm to the inside of the right wrist, palm inwards, look at the right hand. (Fig. 11-1)

2、勾手上步 Hook hand and step forward

身體左轉，右掌變勾手，左手向左平移，掌心向內，同時左腳向左上步，腳跟著地，目視左手。（圖 11-2）

Turns left, the right palm changes into hook hand, the left hand moves to the left horizontally, palm inwards, at the same time the left foot step forward to the left, heel to the ground, look at the left hand. (Fig. 11-2)

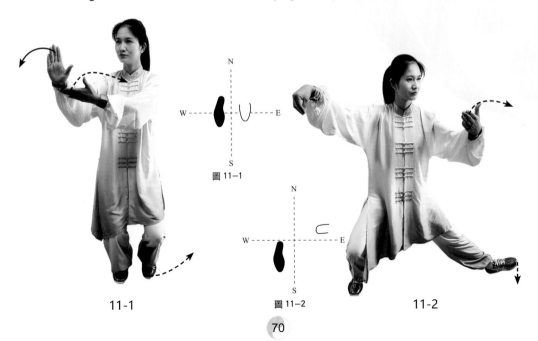

11-1 圖 11-1 圖 11-2 11-2

第十一式 單鞭

Single Whip

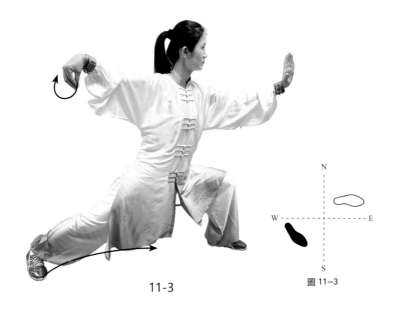

11-3

圖 11-3

3、弓步推掌 Bow step and push palm

身體繼續左轉，左腳前弓，右腳後蹬，成左弓步，同時左手向左、向前翻掌前推，腕與肩平，力達掌根，右手保持勾手不變，目視左手。（圖 11-3）

Continue to turn left, left foot bow step forward, right foot pushes back into left bow stance, at the same time flip the left hand and push to the front left, wrist and shoulder level, the force reaches the palm root, right hand keep as a hook, look at the left hand. (Fig. 11-3)

12 第十二式 高探馬
High Pat on Horse

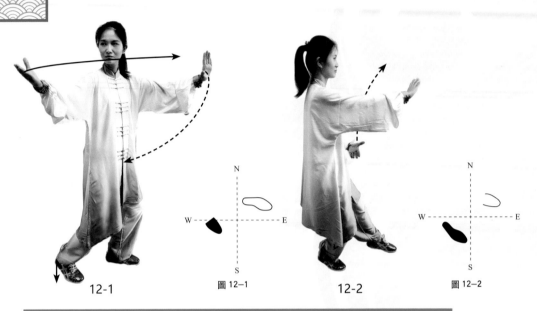

12-1　　　　圖 12-1　　　　12-2　　　　圖 12-2

1、跟步翻掌 Half step forward and turn over palm

身體微右轉，右腳向左腳後側跟進半步，重心移至右腳，左腳腳跟微提起，同時右勾手變掌再外旋翻掌，掌心向上，目視右手。（圖 12-1）

Turn slightly to the right, right foot retracts to the back side of the left foot to form a half-step, the center of gravity moves to the right foot, left foot heel slightly lifts, at the same time release right hook hand to palm, palm upwards, look at the right hand. (Fig. 12-1)

2、虛步推掌 Empty step and push arm

身體左轉，右掌經右耳側向前推出，掌心向前，腕與肩平，左手外旋收至左腰側，掌心向上，同時左腳微提起再向前移，腳尖點地，成左虛步，目視右手。（圖 12-2）

Turns left, push the right palm forward through the right ear side, palm faces forward, the wrist and shoulder level, rotate the left hand externally and retract it to the left waist side, palm upwards, at the same time, the left foot slightly lifts and then points forward, the toes to the ground to form the left empty stance, look at the right hand. (Fig. 12-2)

第十三式 右蹬腳
Kick with Right Heel

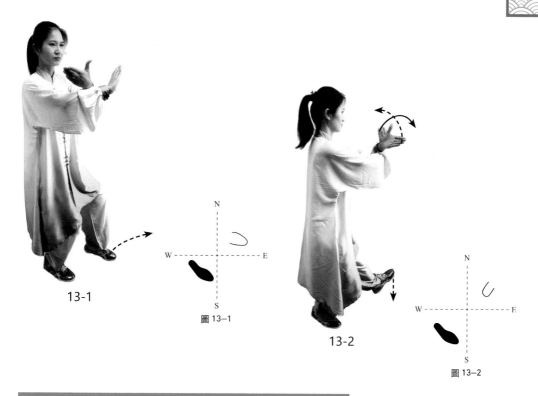

13-1

圖 13—1

13-2

圖 13—2

1、右轉穿掌 Turn right and cross palm

身體微右轉，左掌上穿至右手前臂內側，掌心向內，目視前方。（圖 13-1）

Turn slightly to the right, cross left palm to the inner side of the right forearm, palm inwards, look straight ahead. (Fig. 13-1)

2、左轉上步 Turn Left and step forward

身體左轉，左腳向左前上步，目視兩掌。（圖 13-2）

Turn left, left foot steps forward to the left, look at both hands. (Fig. 13-2)

13 第十三式 右蹬腳
Kick with Right Heel

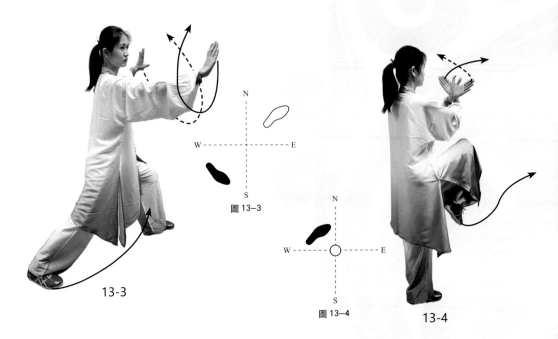

圖 13-3

13-3

圖 13-4

13-4

3、 弓步分掌 Bow stance and open palms

身體左轉，左腳前弓，右腳後蹬，成左弓步，同時兩臂向兩側劃弧分開，掌心向外，目視右掌。（圖 13-3）

Turn left, left foot bow step forward, right foot pushes back into left bow stance, at the same time two arms open in an arc, palms outward, look at right hand. (Fig. 13-3)

4、 提膝合臂 Lift knee and close arms

兩臂劃弧相合於胸前，掌心向內，同時提右膝，目視兩掌。（圖 13-4）

Arms draw a downward arc and come together in front of the chest, palms inwards, at the same time lift right knee, look at both hands. (Fig. 13-4)

第十三式 右蹬腳

Kick with Right Heel

5、 蹬腳分掌 Kick heel and open arms

身體右轉，右腳以腳跟為力點向右前方蹬出，同時兩臂劃弧分開，右臂和右腿上下相對，目視右掌。（圖 13-5）

Turn right, expressing force through the right heel and kick to front right, at the same time open arms in an arc, right arm above right leg, look at the right hand. (Fig. 13-5)

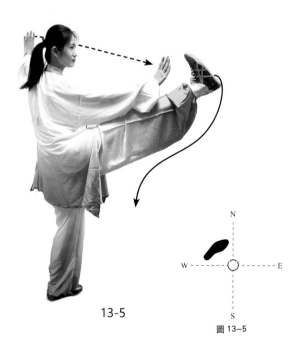

13-5

圖 13—5

14 第十四式 雙峰貫耳
Strike Opponent's Ears with Both Fists

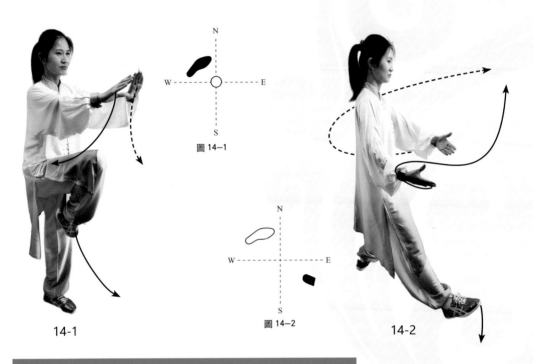

14-1

圖 14—1

圖 14—2

14-2

1、 屈膝合掌 Bend knee and close palms

左腿屈膝，右小腿屈膝回收，腳尖下垂，同時左手向右與右手相合，掌心向下，目視兩掌。（圖 14-1）

Bend left knee, right hamstring curls and retracts, toes point downwards, at the same time, left hand to the right, comes together with the right hand, palms downwards, look at both hands. (Fig. 14-1)

2、 落腳翻掌 Drop foot and turn over palm

右腳向右前方下落，同時兩臂外翻，掌心斜向上，目視前方。（圖 14-2）

Right foot lands on front right, at the same time flip both arms outwards, look straight ahead. (Fig. 14-2)

第十四式 雙峰貫耳
Strike Opponent's Ears with Both Fists

14

3、 弓步貫拳 Bow stance and strike punch

身體右轉，右腳前弓，左腳後蹬，成右弓步，同時兩掌變拳劃弧向前貫打，拳眼斜向下，目視兩拳。（圖 14-3）

Turn right, right foot bow step forward, left foot pushes back into right bow stance, at the same time two fists punch forward in an arc, fist-eyes oblique downwards, look at the fists. (Fig. 14-3)

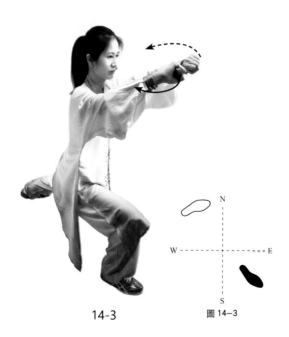

14-3

圖 14-3

15

第十五式 轉身左蹬腳
Turn and Kick with Left Heel

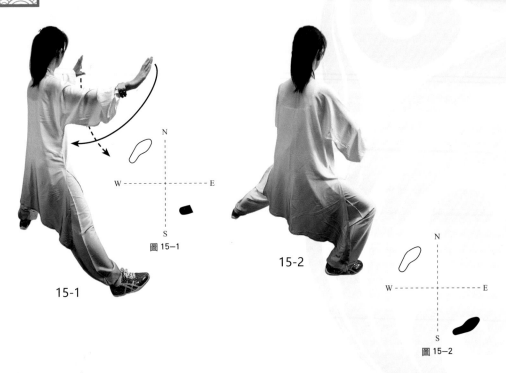

15-1

圖 15—1

15-2

圖 15—2

1、後坐變掌 Sit back and fists become palms

身體左轉，重心左移，右腳尖上翹，同時兩拳變掌劃弧分開，目視左掌。（圖 15-1）

Turn left, shift the body weight to the left, right toes upturn, at the same time two arms split in an arc, fists become palms, look at the left hand. (Fig. 15-1)

2、右移落掌 Shift right and drop palms

重心右移，兩掌下落至兩胯旁，目視前方。（圖 15-2）

Shift the body weight to the right, drop two palms to the side of hips, look straight ahead. (Fig. 15-2)

第十五式 轉身左蹬腳

Turn and Kick with Left Heel

3、提膝合臂 Lift knee and close arms

兩臂劃弧相合於胸前，掌心向內，同時提左膝，目視兩掌。（圖 15-3）

Arms draw a downward arc and come together in front of the chest, palms inwards, at the same time lift left knee, look at both hands. (Fig. 15-3)

4、蹬腳分掌 Kick heel and open arms

身體右轉，左腳以腳跟為力點向左前方蹬出，同時兩臂劃弧分開，左臂和左腿上下相對，目視左掌。（圖 15-4）

Turn right, expressing force through the left heel and kick to front left, at the same time open arms in an arc, left arm above left leg, look at the left hand. (Fig. 15-4)

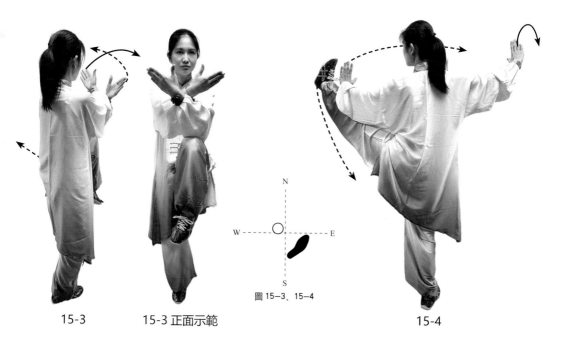

圖 15-3、15-4

15-3　　　　15-3 正面示範　　　　15-4

16 第十六式 左下勢獨立
Snake Creeps Down（Left）

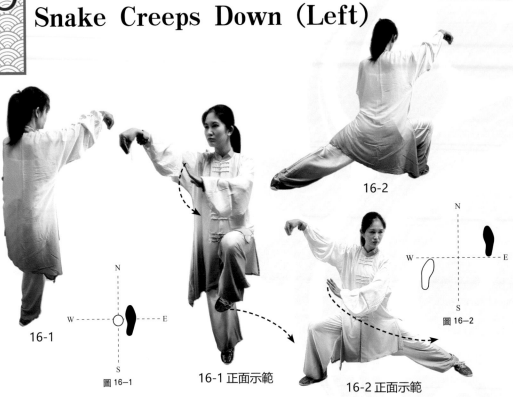

16-2

16-1

圖 16-1

16-1 正面示範

圖 16-2

16-2 正面示範

1、 垂腿勾手 Curl knee and hook hand

身體右轉，左腳屈膝回收，腳尖下垂，同時右掌變勾手，左掌經面前劃弧至右肩前，目視右手。（圖 16-1）

Turn right, left knee curls and retracts, toes point downwards, at the same time, right palm forms hook, left palm passes the face to the front of right shoulder in an arc, look at the right hand. (Fig. 16-1)

2、 屈膝撤步 Bend knee and step backward

右腿屈膝，左腳向左後方撤步，腳掌先著地，左掌下落至右肋前，目視左腳。（圖 16-2）

Right knee bends, drop the ball of left foot backwards to the left, left hand down to the front of right rib cage, look at the left foot. (Fig. 16-2)

第十六式 左下勢獨立

Snake Creeps Down（Left）

3、僕步穿掌 Crouch stance and cross palms

身體左轉，右腿繼續下蹲成僕步，左掌經腹前沿左腿向左穿出，掌心向右，目視左手。
（圖 16-3）

Turn left, right foot squarts down to form crouch stance, extend left palm along the inside edge of left leg to the left, palm to the right, look at the left hand. (Fig. 16-3)

4、弓步挑掌 Bow stance and upturn palms

身體繼續左轉，左腳前弓，右腳後蹬，成左弓步，同時左掌向左前穿，右勾手內旋，勾尖向上，目視左手。 （圖 16-4）

Turn left, left foot bow step forward, right foot pushes back into left bow stance, at the same time upturn left palm to the front, right hook hand turns inwards, hook facing up, look at the left hand. (Fig. 16-4)

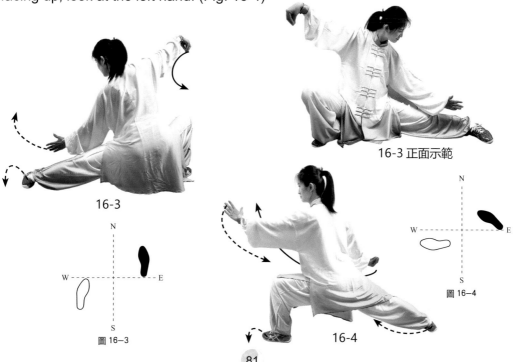

16-3

16-3 正面示範

圖 16-3

16-4

圖 16-4

16 第十六式 左下勢獨立
Snake Creeps Down（Left）

5、提膝挑掌 Lift knee and upturn palms

重心全部移至左腿，右腿屈膝上提，腳尖下垂，同時右勾手變掌上挑，掌心向左，左掌下按至左胯旁。（圖 16-5）

Move whole body weight to the left leg, lift right knee, toes down, at the same time right hook becomes palm and upturn, palm to the left, left palm press down to the side of left hip. (Fig. 16-5)

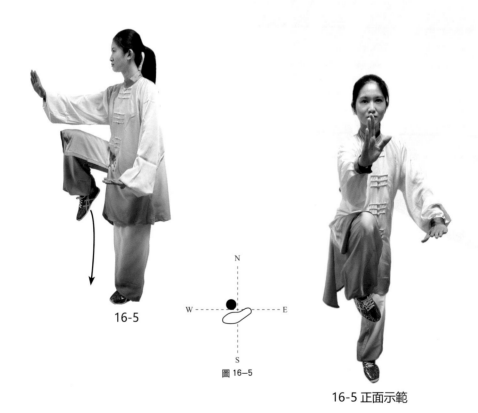

16-5

圖 16－5

16-5 正面示範

第十七式 右下勢獨立

Snake Creeps Down（Right）

17

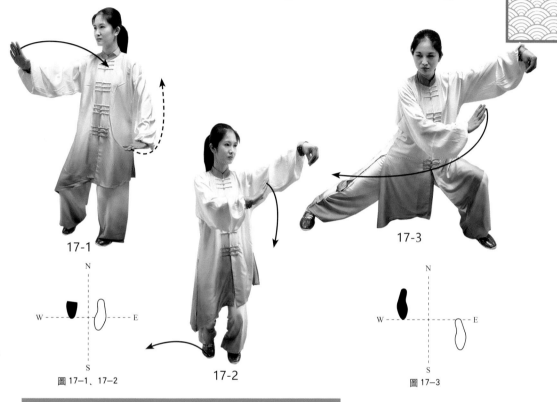

17-1

17-3

圖 17−1、17−2

17-2

圖 17−3

1、落腳勾手 Drop foot and hook hand

右腳在左腳前下落，腳尖先著地，左腳以腳掌為軸碾轉，左掌變勾手上提，右掌經面前劃弧至左肩前，目視左手。（圖 17-1、17-2）

Drop the ball of right foot in front of left foot, roll left foot around on ball of foot as axis, left palm form hook and lift, right palm passes the face to the front of left shoulder in an arc, look at the left hand. (Fig. 17-1、17-2)

2、屈膝撤步 Bend knee and step backward

左腿屈膝，右腳向右後方撤步，腳掌先著地，右掌下落至左肋前，目視右腳。（圖 17-3）

Left knee bends, drop the ball of right foot backwards to the right, right hand down to the front of left rib cage, look at the right foot. (Fig. 17-3)

17 第十七式 右下勢獨立
Snake Creeps Down（Right）

3、僕步穿掌 Crouch stance and cross palms

身體右轉，左腿繼續下蹲成仆步，右掌經腹前沿右腿向右穿出，掌心向左，目視右手。（圖 17-4）

Turn right, left foot squart down to form crouch stance, extend right palm along the inside edge of right leg to the right, palm to the left, look at the right hand. (Fig. 17-4)

4、弓步挑掌 Bow stance and upturn palms

身體繼續右轉，右腳前弓，左腳後蹬，成右弓步，同時右掌向右前穿，左勾手內旋，勾尖向上，目視右手。 （圖 17-5）

Turn right, right foot bow step forward, left foot pushes back into right bow stance, at the same time upturn right palm to the front, left hook hand turns inwards, hook facing up, look at the right hand. (Fig. 17-5)

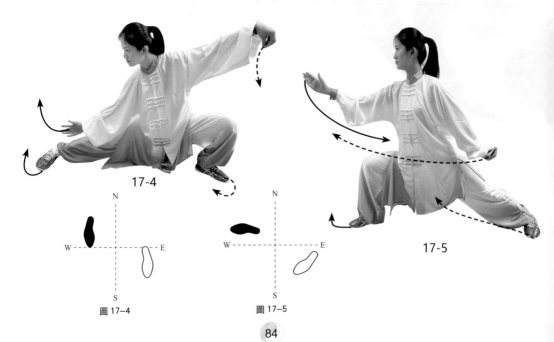

17-4

17-5

圖 17-4 圖 17-5

第十七式 右下勢獨立 17
Snake Creeps Down（Right）

5、提膝挑掌 Lift knee and upturn palms

重心全部移至右腿，左腿屈膝上提，腳尖下垂，同時左勾手變掌上挑，掌心向右，右掌下按至右胯旁。（圖 17-6）

Move whole body weight to the right leg, lift left knee, toes down, at the same time left hook becomes palm and upturn, palm to the right, right palm presses down to the side of right hip. (Fig. 17-6)

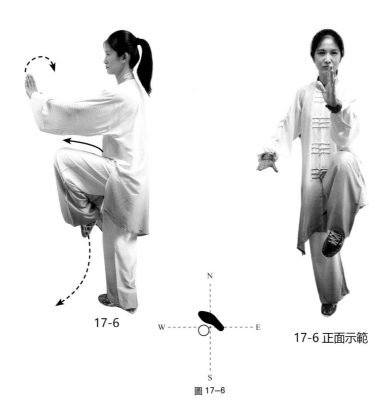

17-6

17-6 正面示範

圖 17-6

18 第十八式 左右穿梭
Jade Lady Weaves Shuttles

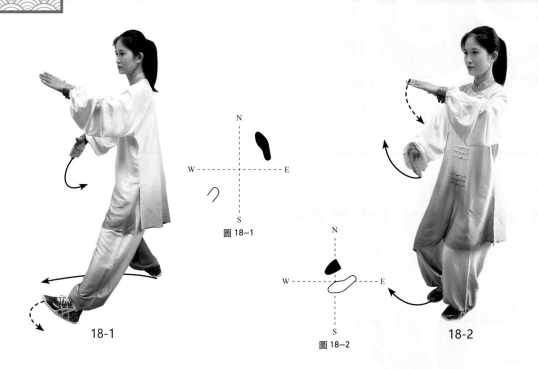

圖 18−1

18-1

圖 18−2

18-2

1、左轉上步 Turn left and step forward

身體左轉，右腿屈膝，左腳向左前方下落，腳跟先著地，目視左手。（圖 18-1）

Turn left, bend right knee, drop the left foot to the front left with heel first, look at the left hand. (Fig. 18-1)

2、收腳抱掌 Withdraw foot and hold palms

身體繼續左轉，重心移至左腳，右腳收至左腳內側，同時兩掌相抱在身體左側，掌心相對，目視左手。（圖 18-2）

Continue to turn left, move body weight to left foot, withdraw right foot to the inside of left foot, at the same time hold two palms to the left, palms facing one another, look at the left hand. (Fig. 18-2)

第十八式 左右穿梭 18
Jade Lady Weaves Shuttles

3、上步滾掌 Step forward and roll palms

身體右轉，右腳向右前方上步，同時兩掌成滾球勢，目視右前方。（圖 18-3）

Turn right, right foot step forward to front right, at the same time roll two palms as rolling a ball, look at front right. (Fig. 18-3)

4、弓步架推 Bow stance and cover push

身體繼續右轉，右腳前弓，左腳後蹬，成右弓步，同時右掌內旋上架至右額上方，左掌向右前方推出，目視左手。（圖 18-4）

Continue to turn right, right foot bow step forward, left foot pushes back into right bow step, at the same time right palm rotates inwards and lift to the right forehead, left palm pushes to the front right, look at the left hand. (Fig. 18-4)

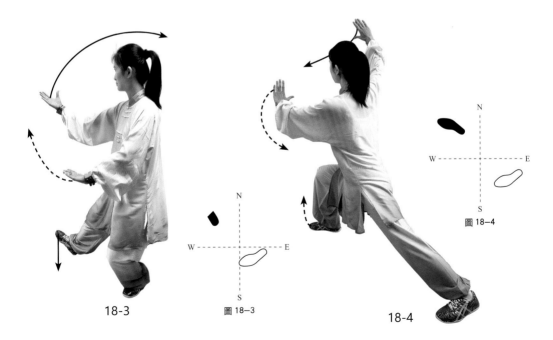

18-3　　　圖 18-3　　　　　18-4

18

第十八式 左右穿梭
Jade Lady Weaves Shuttles

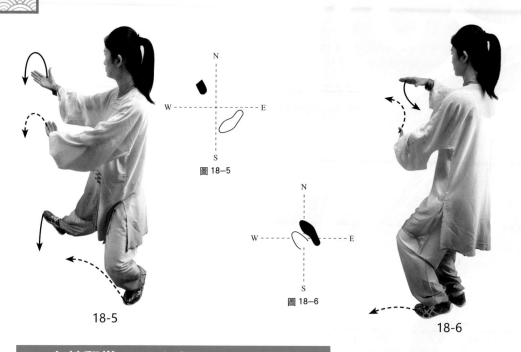

圖 18-5

18-5

圖 18-6

18-6

5、 左轉翻掌 Turn left turn over palm

身體左轉，重心左移，右腳尖上翹，右掌外旋下落，掌心斜向上，目視右手。 (圖 18-5)

Turn left, the center of gravity moves to the left, right toes upturn, right palm rotates externally and brings down, palm faces up, look at the right hand. (Fig. 18-5)

6、 收腳抱掌 Withdraw foot and hold palms

身體右轉，重心移至右腳，左腳收至右腳內側，同時兩掌相抱在身體右側，掌心相對，目視右手。 (圖 18-6)

Turn to the right, the center of gravity moves to the right leg, retract left foot to the inside of right foot, at the same time, hold two palms to the right, palms facing one another, look at the right hand. (Fig. 18-6)

第十八式 左右穿梭 18
Jade Lady Weaves Shuttles

7、上步滾掌 Step forward and roll palms

身體左轉，左腳向左前方上步，同時兩掌成滾球勢，目視左前方。（圖 18-7）

Turn left, left foot step forward to front left, at the same time roll two palms as rolling a ball, look at front left. (Fig. 18-7)

8、弓步架推 Step forward and roll palms

身體繼續左轉，左腳前弓，右腳後蹬，成左弓步，同時左掌內旋上架至左額上方，右掌向左前方推出，目視右手。（圖 18-8）

Continue to turn left, left foot bow step forward, right foot pushes back into left bow step, at the same time left palm rotates inwards and lift to the left forehead, right palm pushes to the front left, look at the right hand. (Fig. 18-8)

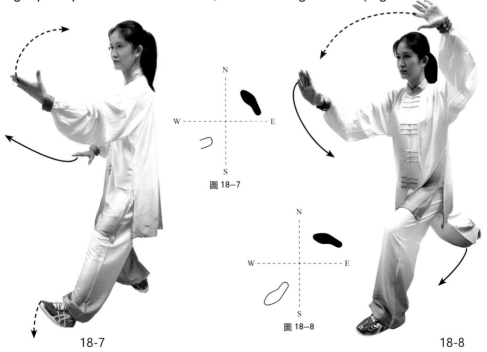

圖 18-7

圖 18-8

18-7

18-8

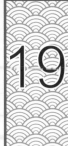

19

第十九式 海底針
Needle at Sea Bottom

1、 跟步提按 Half step forward and lift press

右腳跟上半步，重心右移，左腳微提起，右掌劃弧上提，掌心向左，同時左掌劃弧向右按掌，掌心向下，目視前方。（圖 19-1、19-2）

Right foot half step forward, the center of gravity moves to the right, lift left foot slightly up, right palm lifts up in an arc, palm to the left, at the same time left palm presses to the right in an arc, palm down, look straight ahead. (Fig. 19-1、19-2)

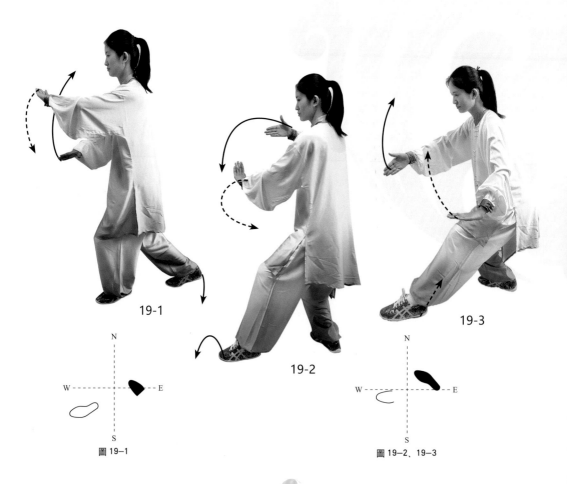

19-1

19-2

19-3

圖 19-1

圖 19-2、19-3

第二十式 閃通背
Fan through back

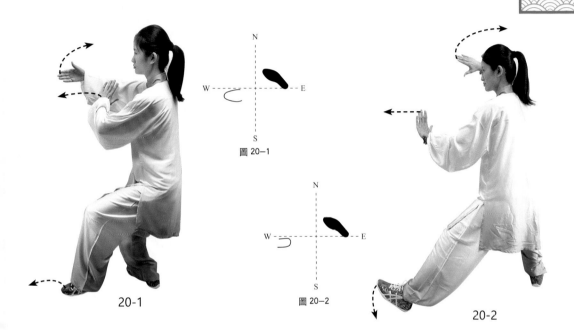

圖 20-1

20-1

圖 20-2

20-2

1、提腳合臂 Lift foot and close arm

身體右轉，左腳微提起，右掌回抽，同時右掌內旋，左掌上穿與右臂相合，掌心向右，目視前方。（圖 20-1）

Turn right, lift left foot slightly up, right palm draws back, while right palm rotates internally, left palm threads upwards together with the right arm, palm to the right, look straight ahcad. (Fig. 20-1)

2、上步架掌 Step forward and block palm

身體左轉，左腳向前上步，腳跟著地，同時兩臂微向上架，目視前方。（圖 20-2）

Turn left, left foot step forward, heel to the ground, while both arms slightly block upwards, look straight ahead. (Fig. 20-2)

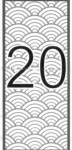

20 第二十式 閃通背
Fan through Back

3、 弓步架推 Bow step and block push

身體繼續左轉，左腳前弓，右腳後蹬，成左弓步，同時左手向前推出，腕與肩平，力達掌根，右臂向頭頂上架，拇指向下，掌心向外，目視左手。 （圖 20-3）

Continue to turn left, left foot bow step forward, right foot pushes back into left bow stance, while the left hand push forward, wrist and shoulder level, the force reaches the palm root, right arm block to the top of the forehead, thumb down, palm outwards, look at the left hand. (Fig. 20-3)

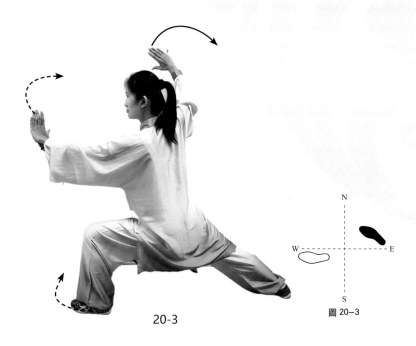

20-3

圖 20-3

第二十一式 轉身搬攔捶

Turn to Deflect Downwards, Parry and Punch

21

1、後坐扣腳 Sit back and foot internal buckle

身體右轉，重心右移，左腳尖內扣，右掌劃弧下落右胯前，目前前方。（圖 21-1、21-2）

Turn right, the center of gravity moves to the right, right toes buckle internally, right palm presses down to the side of right hip in an arc, look straight ahead. (Fig. 21-1、21-2)

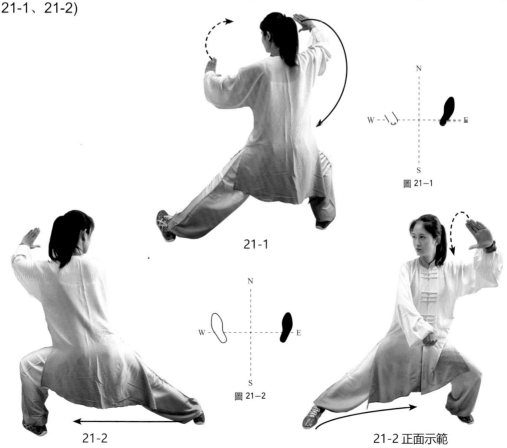

圖 21—1

21-1

圖 21—2

21-2

21-2 正面示範

21

第二十一式 轉身搬攔捶
Turn to Deflect Downwards, Parry and Punch

2、收腳變拳 Withdraw foot and form fist

身體繼續右轉，重心左移，右腳收至左腳內側，同時右掌變拳收至左肘內下側，拳眼向內，目視右前方。（圖 21-3）

Continue to turn right, the center of gravity moves to the left, withdraw right foot to the inside of left foot, while the right palm forms fist and rest to the inside of left elbow, fist-eye inwards, look at the front right. (Fig. 21-3)

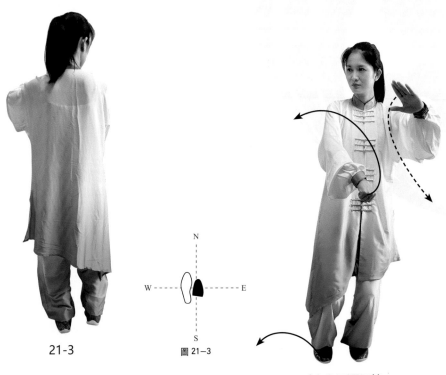

21-3

圖 21-3

21-3 正面示範

第二十一式 轉身搬攔捶

Turn to Deflect Downwards, Parry and Punch

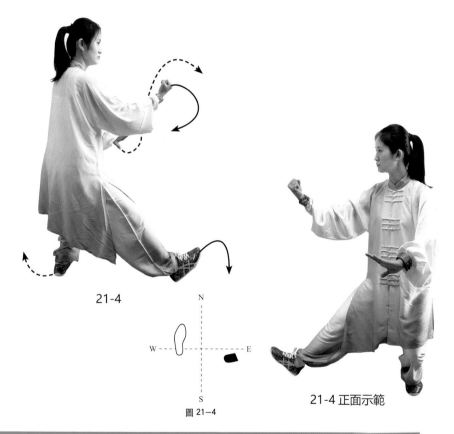

21-4

圖 21—4

21-4 正面示範

3、上步搬拳 Step forward and deflect downwards

身體右轉，右腳向前上步，同時右拳經胸前向前搬拳，左掌下落至左胯旁，目視右拳。
（圖 21-4）

Turn right, right foot step forward, while right fist passes the chest and deflect downwards, left palm rest to the side of left hip, look at the right fist. (Fig. 21-4)

21 第二十一式 轉身搬攔捶

Turn to Deflect Downwards, Parry and Punch

4、擺腳攔掌 Swing toes and parry

身體繼續右轉，右腳尖外擺，同時右臂螺旋向右至右後方，左臂向右攔掌，掌心向上，目視左手。（圖 21-5）

Continue to turn right, swing right toes outwards, at the same time right arm spiral from front to back, parry left arm to the right, look at the left hand. (Fig. 21-5)

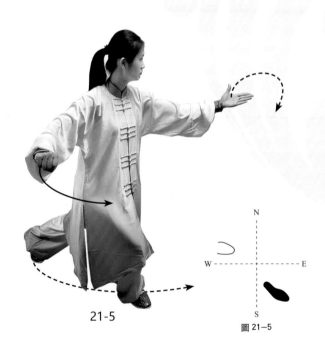

21-5

圖 21—5

第二十一式 轉身搬攔捶

Turn to Deflect Downwards, Parry and Punch

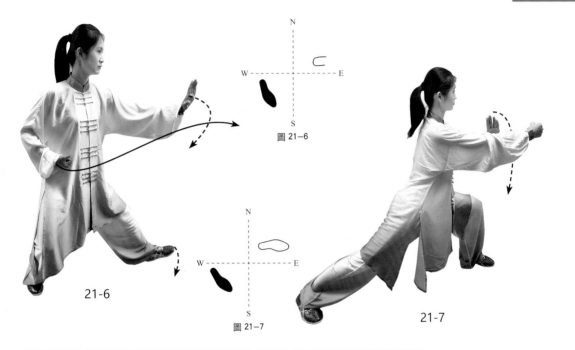

圖 21-6

21-6

圖 21-7

21-7

5、 上步收拳 Step forward and withdraw fist

左腳向前上步，左手立掌，右拳劃弧收至右腰間，目視左掌。（圖 21-6）

Left foot step forward, left fingers point up, withdraws right fist in an arc to the side of right waist, look at the left palm. (Fig. 21-6)

6、 弓步打拳 Bow step and punch

身體左轉，左腳前弓，右腳後蹬，成左弓步，右拳向前螺旋打出，拳眼向上，左掌附於右臂內側，目視右拳。（圖 21-7）

Turn left, left foot bow step forward, right foot pushes back into bow stance, right fist spiral and punch forward, fist-eye upwards, left palm beside the inside of right forearm, look at the right fist. (Fig. 21-7)

22 第二十二式 如封似閉
Apparent Close Up

1、 穿手變掌 Cross hand and form palm

左掌經右臂下側向前穿出，同時右拳變掌，掌心向上，目視前方。（圖 22-1、22-2)

Place left palm to the lower side of right arm and slide forward, while right fist becomes palm, palms up, look straight ahead. (Fig. 22-1、22-2)

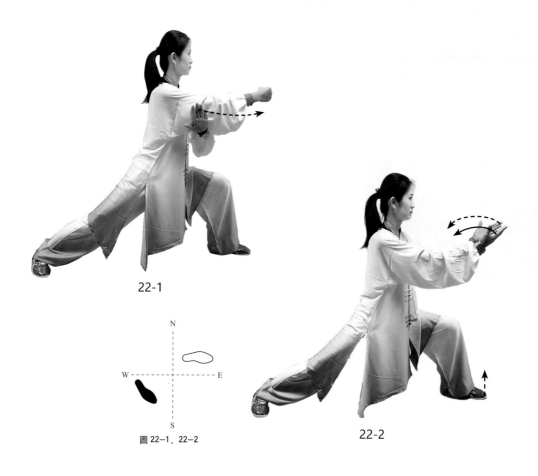

22-1

圖 22-1、22-2

22-2

第二十二式 如封似閉
Apparent Close Up

2、後坐收掌 Sit back and withdraw palm

重心右移，左腳尖上翹，同時兩臂向後屈臂回收，掌心斜向上，目視兩掌。（圖 22-3）

The center of gravity moves to the right, left toes upturn, while elbows bend and withdraw both arms back, palms oblique upwards, look at both palms. (Fig. 22-3)

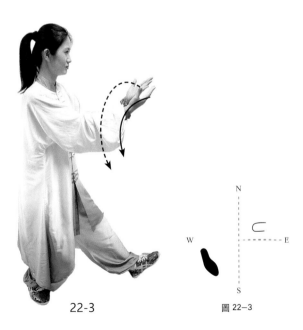

22-3

圖 22-3

22

第二十二式 如封似閉
Apparent Close Up

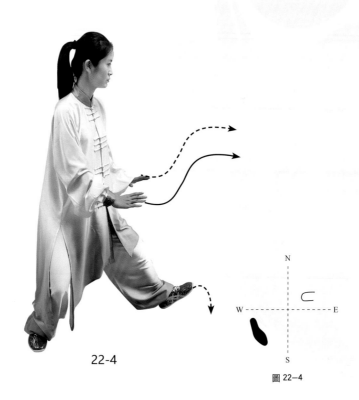

22-4

圖 22—4

3、翻掌下按 Turn over plams and press down

兩臂內旋，兩掌翻轉向下按掌，目視前方。 （圖 22-4）

Rotate both arms inwards, palms down and press down, look straight ahead. (Fig. 22-4)

第二十二式 如封似閉
Apparent Close Up

22

4、弓步前按 Bow step and press forward

身體左轉，左腳前弓，右腳後蹬，成左弓步，同時兩掌自下向上再向前按出，腕於肩平，力達掌根，目視前方。（圖 22-5）

Turn left, left foot bow step forward, right foot pushes back, into the left bow stance, at the same time two palms press up and forward, wrists level with shoulders, the force reaches the palm root, look straight ahead. (Fig. 22-5)

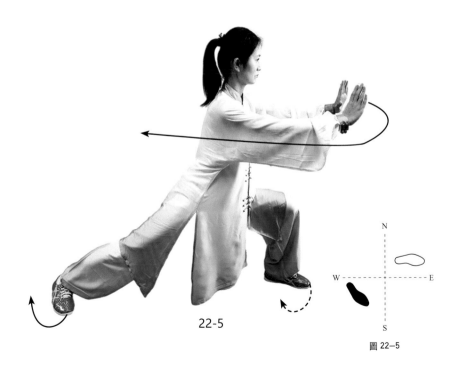

22-5

圖 22-5

23 第二十三式 十字手
Cross Hands

1、右轉分掌 Turn right and open palms

身體右轉，重心右移，左腳尖內扣，右腳尖外擺，同時兩手劃弧分開，腕與肩平，目視右手。（圖 23-1）

Turn right, the center of gravity moves to the right, the left toes buckle internally, the right toes swing outwards, at the same time the two arms are drawn apart in an arc, the wrists are flat with the shoulder, look at he right hand. (Fig. 23-1)

2、扣腳合臂 The foot internal buckle and cross arms

身體左轉，重心左移，右腳尖內扣，同時兩臂向下交叉合臂，左臂在外，兩掌掌心均向內，目視前方。（圖 23-2）

Turn left, the center of gravity moves to the left, the right foot buckle internally, at the same time the two arms move down and cross, the left arm is outside, both palms face inwards, look straight ahead. (Fig. 23-2)

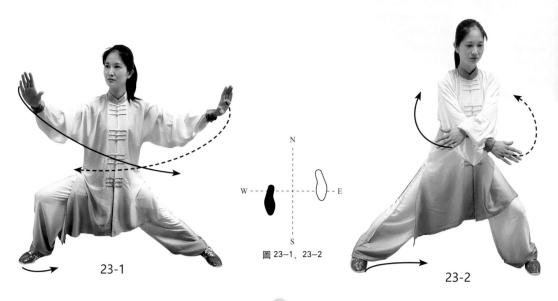

23-1

圖 23-1、23-2

23-2

第二十三式 十字手
Cross Hands

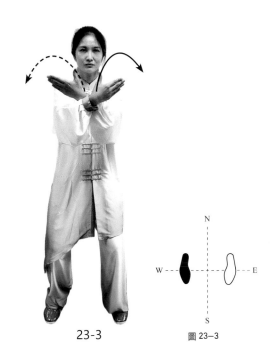

23-3 　　　　　　　　圖 23-3

3、收腳合臂 Withdraw foot and cross arms

身體微右轉，右腳收回至左腳內側，成開立步，與肩同寬，同時兩臂外旋上托，成十字手，右手在外，腕與肩平，兩掌掌心均向內，目視前方。（圖 23-3）

Turn slightly to the right, the right foot retracts to the inside of the left foot and form upright stance, with the feet shoulder width apart, at the same time two arms rotate externally and push upwards, two hands cross, the right hand is outside, the wrists and the shoulder level, both palms inwards, look straight ahead. (Fig. 23-3)

24 第二十四式 收勢
Closing Form

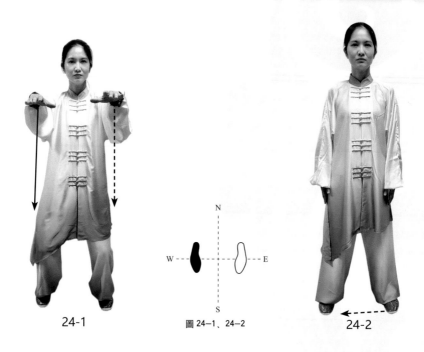

24-1 　　　圖 24-1、24-2 　　　24-2

1、翻掌平抹 Turn over and wipe palms

兩掌微微外掤，內旋翻掌，分開平抹，兩掌掌心均向下，肩寬肩高，目視前方。（圖 24-1）

Two palms push outwards, turn the palms over, palms downwards, then spread them apart, shoulder width and shoulder height, look straight ahead. (Fig. 24-1)

2、落掌直立 Drop palms and body upright

兩掌慢慢下落至兩腿外側，身體由屈蹲慢慢直立，目視前方。（圖 24-2）

Slowly drop the arms to sides of thighs, raise the body uprights, look straight ahead. (Fig. 24-2)

第二十四式 收勢
Closing Form
24

3、 並步還原 Return to equal stance

重心移至右腳，左腳收至右腳內側，右腳並腳還原。 （圖 24-3）

The center of gravity moves to the right foot, the left foot retracts to the inside of the right foot, the feet come together. (Fig. 24-3)

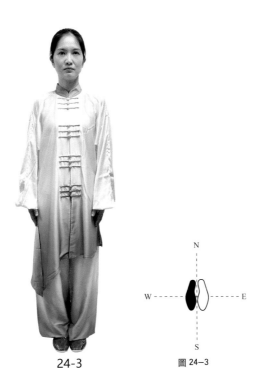

24-3

圖 24-3

【太極扇】

武術/廣場舞/表演扇

可訂制LOGO

紅色牡丹

粉色牡丹

黃色牡丹

紫色牡丹

黑色牡丹

藍色牡丹

綠色牡丹

黑色龍鳳

紅色武字

黑色武字

紅色龍鳳

金色龍鳳

純紅色

紅色冷字

紅色功夫扇

紅色太極

打開淘寶天貓APP

掃碼進店

微信掃一掃

進入小程序購買

【專業太極刀劍】

晨練/武術/表演/太極劍

打開淘寶天貓
掃碼進店

手工純銅太極劍

神武合金太極劍

桃木太極劍

平板護手太極劍

手工銅錢太極劍

鏤空太極劍

手工純銅太極劍

神武合金太極劍

劍袋 · 多種顏色、尺寸選擇

銀色八卦圖伸縮劍

銀色花環圖伸縮劍

龍泉寶刀

棕色八卦圖伸縮劍

紅棕色八卦圖伸縮劍

微信掃一掃
進入小程序購買

【學校學生鞋】

多種款式選擇·男女同款

可定制logo

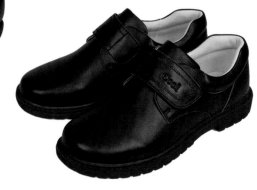

檢測報告　　　　商品註冊證

打開淘寶天貓APP

掃碼進店

微信掃一掃

進入小程序購買

【武術/表演/比賽/專業太極鞋】

正紅色【升級款】
XF001 正紅

打開淘寶天貓
掃碼進店

微信掃一掃
進入小程序購買

藍色【經典款】
XF8008-2 藍

黃色【經典款】
XF8008-2 黃色

紫色【經典款】
XF8008-2 紫色

正紅色【經典款】
XF8008-2 正紅

黑色【經典款】
XF8008-2 黑

綠色【經典款】
XF8008-2 綠

桔紅色【經典款】
XF8008-2 桔紅

粉色【經典款】
XF8008-2 粉

XF2008B（太極圖）白

XF2008B（太極圖）黑

XF2008-2 白

XF2008-3 黑

5634 白

XF2008-2 黑

【太極羊 · 專業武術鞋】

兒童款 · 超纖皮

打開淘寶APP
掃碼進店

XF808-1 銀

XF808-1 白

XF808-1 紅

XF808-1 金

XF808-1 藍

XF808-1 黑

XF808-1 粉

短袖款

长袖款

微信掃一掃

進入小程序購買

【專業太極服】

多種款式選擇・男女同款

黑白漸變仿綢

淺棕色牛奶絲

白色星光麻

亞麻淺粉中袖

白色星光麻

真絲綢藍白漸變

【正版教學光盤】

正版教學光盤 太極名師 冷先鋒 DVD包郵

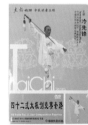

打開淘寶天貓APP

掃碼進店

微信掃一掃

進入小程序購買

香港國際武術總會裁判員、教練員培訓班
常年舉辦培訓

　　香港國際武術總會培訓中心是經過香港政府注册、香港國際武術總會認證的培訓部門。爲傳承中華傳統文化、促進武術運動的開展，加强裁判員、教練員隊伍建設，提高武術裁判員、教練員綜合水平，以進一步規範科學訓練爲目的，選拔、培養更多的作風硬、業務精、技術好的裁判員、教練員團隊。特開展常年培訓，報名人數每達到一定數量，即舉辦培訓班。

報名條件：熱愛武術運動，思想作風正派，敬業精神强，有較高的職業道德，男女不限。

培訓內容：1.規則培訓；2.裁判法；3.技術培訓。考核內容：1.理論、規則考試；2.技術考核；3.實際操作和實踐(安排實際比賽實習)。經考核合格者頒發結業證書。培訓考核優秀者，將會錄入香港國際武術總會人才庫，有機會代表參加重大武術比賽，并提供宣傳、推廣平臺。

聯系方式
深圳：13143449091(微信同號)
　　　13352912626(微信同號)
香港：0085298500233(微信同號)

國際武術教練證　　國際武術裁判證

微信掃一掃

進入小程序

香港國際武術總會第三期裁判、教練培訓班

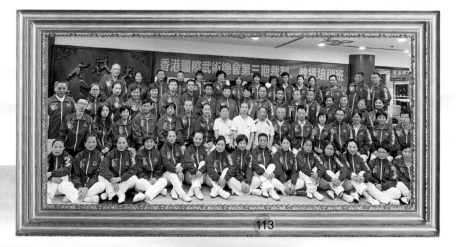

打開淘寶APP

掃碼進店

【出版各種書籍】

申請書號>設計排版>印刷出品
>市場推廣

港澳台各大書店銷售

冷先鋒

國際武術大講堂系列教程之一
《24 式簡化太極拳》

香港先鋒國際集團 審定

太極羊集團　贊助

香港國際武術總會有限公司　出版

香港聯合書刊物流有限公司　發行

代理商：台灣白象文化事業有限公司

書號：ISBN 978-988-75078-8-8

香港地址：香港九龍彌敦道 525 -543 號寶寧大廈 C 座 412 室

電話：00852-98500233 \91267932

深圳地址：深圳市羅湖區紅嶺中路 2018 號建設集團大廈 B 座 20A

電話：0755-25950376\13352912626

臺灣地址：401 臺中市東區和平街 228 巷 44 號

電話：04-22208589

印次：2021 年 6 月第一次印刷

印數：10000 冊

責任編輯：冷先鋒

責任印製：冷修寧

版面設計：明栩成

圖片攝影：張念斯

網站：hkiwa.com　Email: hkiwa2021@gmail.com